Images of America
Pleasant Hill

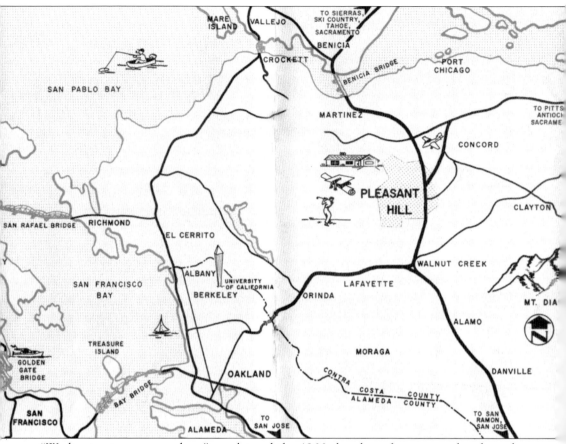

"We live western . . . modern," proclaimed the 1966 chamber of commerce brochure from which this map comes. Promoting the combination of city and country living, the brochure extols the community's proximity both to recreation areas and to the cities of San Francisco and Oakland.

ON THE COVER: The minutes from a Pleasant Hill Parent-Teacher Association meeting included plans for a farm produce sale, which is likely the market pictured here. Held on the Walnut Creek–Pacheco Highway at Victory Road (today's Contra Costa and Monument Boulevards), this market would have helped travelers identify the once-obscure community that sat between several larger cities. (Courtesy Pleasant Hill Historical Society.)

IMAGES of America
PLEASANT HILL

Adam P. Nilsen

Copyright © 2007 by Adam P. Nilsen
ISBN 978-0-7385-5565-2

Published by Arcadia Publishing
Charleston SC, Chicago IL, Portsmouth NH, San Francisco CA

Printed in the United States of America

Library of Congress Catalog Card Number: 2007928550

For all general information contact Arcadia Publishing at:
Telephone 843-853-2070
Fax 843-853-0044
E-mail sales@arcadiapublishing.com
For customer service and orders:
Toll-Free 1-888-313-2665

Visit us on the Internet at www.arcadiapublishing.com

To my amazing family

Contents

Acknowledgments 6

Introduction 7

1. Early Pleasant Hill 9

2. 1900s–1910s 23

3. 1920s–1930s 37

4. 1940s–1950s 51

5. 1960s–1970s 79

6. 1980s–Today 115

Acknowledgments

I owe a great deal of gratitude to more people than I can mention. I am especially grateful to the Pleasant Hill Historical Society and the Friends of Rodgers Ranch for both financial support and access to their collections. Special thanks go to members Sarah Young, Ted Winslow, Denise Koroslev, Dana Mathews, Marion Corder, Sparkles Huber, and Ellen Stevahn. The late Vallie Jo Whitfield contributed to this book through her 1981 *History of Pleasant Hill, California*. Thanks also go to P. Christiaan Klieger, Kip and Stella Kramer, Genene Welch, Nick Cimino, Betsy Webb, and my editor, Devon Weston, with Arcadia Publishing. All of the people mentioned in the text as contributors of photographs and stories went out of their way to provide these materials, which I greatly appreciate. Thank you most of all to my parents, Paul and Julie, my sister Sonja, and my partner, Chad, for their help and support and for sharing the Pleasant Hill experience with me.

All images, unless otherwise noted, are courtesy of the Pleasant Hill Historical Society. The following image sources will be credited as follows: Contra Costa County Historical Society (CCCHS), Friends of Rodgers Ranch (FORR), City of Pleasant Hill Planning Division (PH Planning), and City of Pleasant Hill Redevelopment Agency (PH Redevelopment).

INTRODUCTION

A first-grade class at Valhalla Elementary School in Pleasant Hill became pen pals with an East Coast school in 1986. While writing a class letter, the teacher asked, "What should we tell them about Pleasant Hill?" The six-year-old mental wheels spun, and a girl raised her hand. "There are a lot of hills, and it is very pleasant!" she said. While many might agree with this description, defining a Pleasant Hill identity has been a complex project for many residents over the years. Not only has the community sought to protect its hilliness and enhance its pleasantness, it has also tried to create and re-create identities and a sense of pride.

I use "identities" in plural because Pleasant Hill people possess many different identities simultaneously that shift with time. For instance, while some members of the community called Pleasant Hill a "city of windmills" in the 1960s, certainly not everybody was of this mind or even paid attention to the towering turbines. If someone called Pleasant Hill a city of windmills today, heads would tilt in puzzlement—the handful of remaining windmills are largely invisible. This identity, while not universally accepted to begin with, has therefore come and gone. The identities of any place are constantly changing and being reinvented by residents, businesspeople, advertisers, and the media. Though people have attempted the feat, it is impossible to define Pleasant Hill in one succinct way. Each person who knows Pleasant Hill has a different concept of it.

For much the area's history, residents have been concerned with identity in three senses. First, Pleasant Hill was not always a place with its own zip code and city limits; in this sense, its identity has not always been distinct from other communities'. Second, residents have discussed the city's identity in terms of its image since the 1940s, highlighting certain features of it, beautifying it, and making it into an object of pride. Third, residents have sought symbols that support the community's distinctness and image. These efforts have taken fascinatingly different forms, and as this book moves chronologically through Pleasant Hill's history, it explores how these efforts have come into play at different times.

The search for distinctness took place mostly before the city's incorporation in 1961. There was, certainly, a time when defining Pleasant Hill's identity simply meant drawing boundaries for a school district. Pleasant Hill, with only a schoolhouse as its center, was a gray area between Pacheco, Martinez, Concord, and Walnut Creek—all part of the former Rancho Las Juntas. As the local economy grew, influenced by automobile and rail travel, the seeds (or, more appropriate for Pleasant Hill, the walnuts) were planted for the formation of a distinct identity.

The situation remained this way, more or less, until the post–World War II housing boom, when families flocked to young suburbs like Pleasant Hill. More people meant more social organizations under the city's name; the Pleasant Hill Women's Club, *Pleasant Hill News*, and Pleasant Hill Grange, for example, supported a sense of cohesion between locals and a distinctness from surrounding communities. Discussion about formalizing this distinctness took hold in the mid-1950s, when Walnut Creek and Concord annexed pieces of Pleasant Hill, causing residents to fear the area losing its identity altogether. While discussions about incorporation focused on economics, voters knew that the community's identity was also on the line.

The second kind of identity, the community's image, emerged out of the postwar project of selling homes. Real estate advertisements extolled the pleasures of country life, setting these pleasures in contrast to the city life. Promises of "smog-free, fog-free days" were clearly jabs at the climates of cities like San Francisco and Oakland. They portrayed Pleasant Hill as a suburban utopia with a mild climate, a perfect spot for barbecues and pool parties surrounded by the valley's natural scenery. Simultaneously, these companies peddled an opposing idea: modern living. Pleasant Hill, as one brochure proclaimed, had the "convenience of urban living in a rural atmosphere," and the chamber of commerce's 1963 slogan was "City Shopping, Country Living." This dual identity was an effort to balance city and country, modern and old-fashioned, during a period of transition from agricultural community to suburb. Despite the near erasure of agricultural land, community groups have begun to highlight this past through farm-inspired architecture and celebrations of the remaining patches of rurality.

Enhancing and elaborating on these identities has been an ongoing project as the city has constructed a link between community identity and pride. The first planning committee included a member responsible for the city's "general character," and community forum attendees discussed the city's look and feel. What kinds of buildings should be allowed? What kinds of signs? What should the city landscape next? The city council declared Arbor Day 1964 to be Pleasant Hill Beautification Day, and trees were planted on Contra Costa Boulevard to "not only increase the prestige of the city but add to the property values in the area," as the city manager ironically said. This interplay between development for city revenue and development for community enjoyment and pride has been a common theme in suburbs.

While a broad "look and feel" identity has been important to the city, residents have also toyed with specific symbols to support a general identity. The first was probably the Soldiers' Monument, built in 1927. The 45-foot tower became a way for travelers along Highway 21 (later Contra Costa Highway, then Contra Costa Boulevard) to recognize the otherwise landmark-less Pleasant Hill. Since then, community members have made numerous sites into symbols—and have even created their own from scratch. The monument, the 1920 schoolhouse, and a heritage oak tree join new symbols created specifically for identity building: huts sheltering city limits signs, the Asfothelos daffodil sculpture, and the arch over the new downtown. These symbols, old and new, have been employed in support of the city's identity in places ranging from stationery to postcards to the city's website.

The ultimate symbol that the city has sought has been a center—a downtown area to act as an anchor point of the community. This is a prime example of a community inventing and reinventing its identity—by removing "blighted" structures, centralizing a variety of businesses in a neat, new package, and encouraging community pride. I use the term "development" hesitantly because developing land implies bringing it to its ultimate predetermined destiny, like an infant developing into an adult. Really, development is a conscious process that involves decisions and negotiations about a community's culture; it is not inevitable.

The phenomena that I describe in this book fit in with a broader literature of suburban development. This text raises issues such as the tension between residents, with dreams of happiness and convenience, and developers, with dreams of profit. Scholars have examined the effects of suburbia on racial, gender, and class dynamics, and Pleasant Hill and California suburbs are a part of this. I offer this book, therefore, as a contribution to this literature, but also as an account of the changes that development and identity-making processes bring. These changes themselves are striking—to see how a grassy plain can become an orchard, a post office, and then a Taco Bell is intriguing. Having grown up here myself (that was my own first-grade class, if you had not guessed), I hope this book will call forth memories and bring new understandings of Pleasant Hill.

One
EARLY PLEASANT HILL

"This is a pleasant hill!" "What a pleasant hill!" "Isn't that a pleasant hill?" It is not known who declared the pleasantness of a certain hill, which hill was being admired, or whether the person really used one of these phrases that show up in local lore. One story says that, with the uttering of phrase number two, pioneer Patrick Rodgers decided this area should forever be known as Pleasant Hill. It was probably not that easy, however, and the birth of the community is likely not something that can be traced to a single moment.

The pleasant hill, whichever one it was, lay in a region populated first by the Ohlone and Bay Miwok Indians. Spanish explorers and priests simultaneously sought to expand their empire in the New World and convert these natives to Catholicism through a system of missions, pueblos, and presidios. The early, and often tragic, interactions may seem far removed from today's Pleasant Hill, but they were the basis of the later Mexican government's land system that allowed settlers to petition for land ownership and further displace the native inhabitants.

One of these new settlers was William Welch, an Irishman who came to California in 1812 and married Maria Antonia Galindo of Spanish ancestry. Welch was granted the area called Rancho Las Juntas by the governor of Mexican Alta California in 1844. The Welches spent most of their time in the pueblo of San José, but kept cattle near the sod house they had built on their rancho. Widow Maria Welch moved into this house after her husband's death in 1846, and the land was distributed to the Welches' heirs and eventually sold to new settlers. Today's Pleasant Hill, Walnut Creek, Concord, Pacheco, and Martinez all contain parts of the old rancho, and many of the features on current maps were shaped by the lines drawn during the Spanish period. This chapter explores the pre-20th-century history of the area that is now Pleasant Hill—from its native residents to the Mexican ranchos to the first non–Native American families who called it home . . . and called it Pleasant Hill.

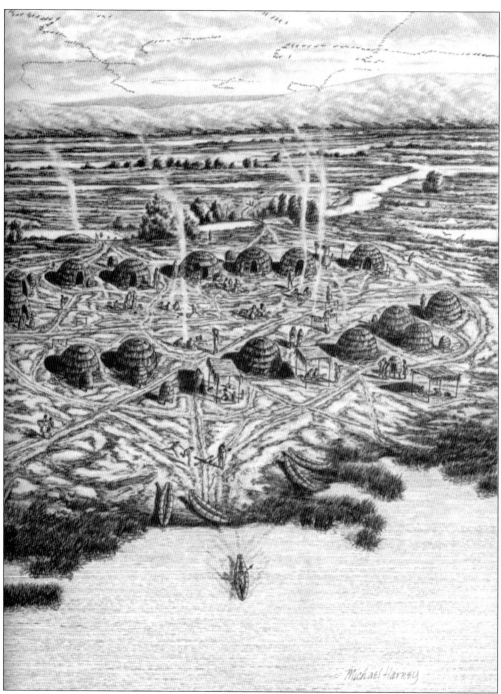

The native people who lived in what is now Pleasant Hill were of the Ohlone and Bay Miwok tribes. Archaeological evidence indicates that people have lived in the Bay Area for at least 8,000 to 10,000 years, and researchers have located former living sites in the Pleasant Hill area. Pictured here are clusters of domed or conical houses that the Ohlones made from willow and tule reeds. (Illustration by Michael Harney, from *The Ohlone Way* by Malcolm Margolin; reproduced by permission of Heyday Books.)

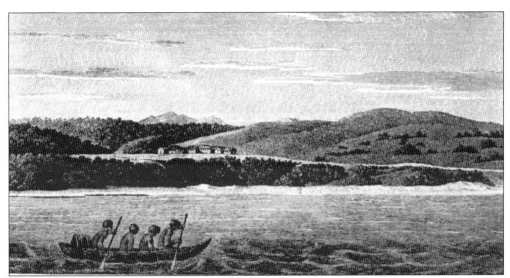

This 1806 engraving shows people presumed to be Ohlones in a tule canoe near the Presidio of San Francisco. The diaries of European explorers describe the natives' hospitality toward the newcomers, but the mission system forced drastic changes on their cultural practices and minimized native land use. Mission records indicate that members of the Chupcan and Tatcan bands of the Bay Miwok tribe, as well as the Carquin band of the Ohlone tribe, were taken and baptized at Mission Dolores in San Francisco and Mission San José in 1810 and 1811. (Artist unknown; original press by T. C. Russell, San Francisco.)

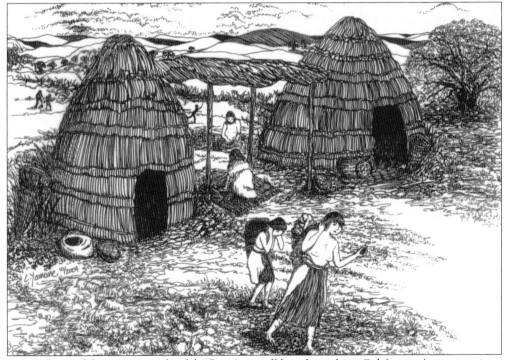

Descendants of the native people of the Bay Area still live throughout California. Artists continue traditional practices such as basket weaving, while others work to revive native languages, dances, and folklore. (Courtesy Rumsien Ohlone artist Linda Yamane.)

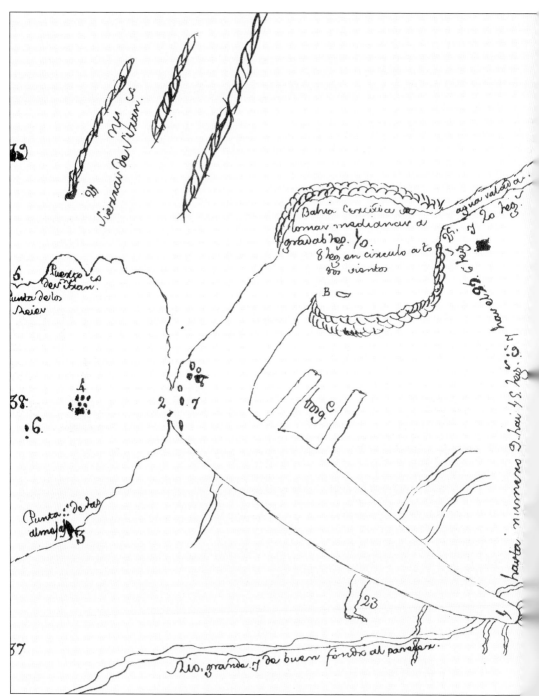

"Llano verde de Zacate," or "Green, grassy plain," is the notation made in the center of this 1775 map, probably describing the valley containing today's Pleasant Hill. This map accompanied the diary of Fr. Vicente Santa María, a Spanish chaplain on the first known European ship to enter San Francisco Bay. It is a variant of one drawn by Fr. Juan Crespí, who had explored California by land with Frs. Francisco Palou and Junípero Serra. The entrance to the San Francisco Bay is seen near the number 2, with the bay extending more eastward than its true shape. San Pablo

12

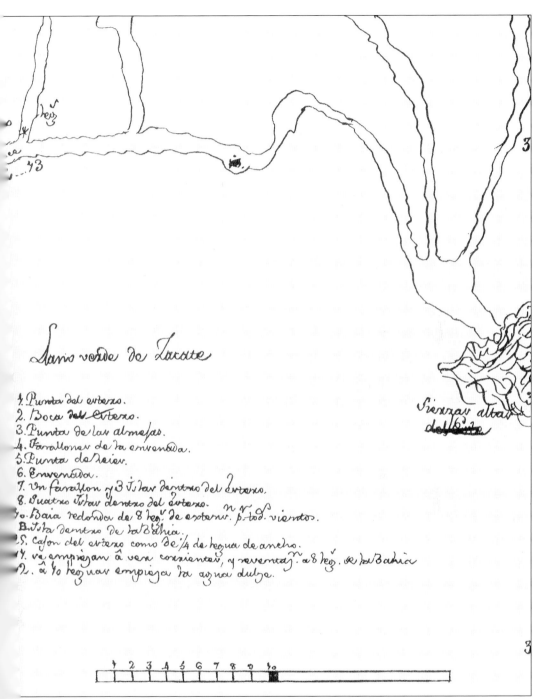

Bay, Carquinez Strait, and the Sacramento River Delta are to the north. Other recognizable features are "Punta de los Reies" (Point Reyes, the 5 at far left), the peninsula (now the island) of Alameda (labeled "bosq.ᵉ," or "forest"), "Puerto de Sⁿ Fran.ᶜᵒ" (Harbor of St. Francis, today's Drake's Bay), and "Punta de las Almejas" (Mussel Point, now Point San Pedro near Pacifica). (Courtesy Sean Galvin.)

Hangman's Tree (left) and Murderer's Creek (below) were supposedly named by a group of surveyors who found a man hanging from a tree on the creek. Another story states that a native person was hanged there for horse stealing, and yet another says hangings happened here more than once. Several trees have been called the Hangman's Tree, one of which fell at the beginning of the 21st century.

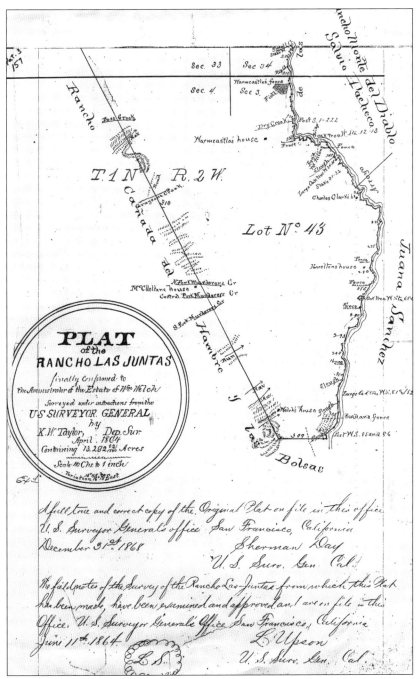

An 1868 map of Rancho Las Juntas, 1 of 15 land grants in Contra Costa, shows the area 18 years after California's statehood. The name referred to the junction of three streams that formed the Arroyo de las Nueces (the Walnut Creek), going north to south on this map. Grayson Creek is seen crossing the boundary with the neighboring rancho near what is now Taylor Boulevard, and McClellan's house was located near today's Palos Verdes Shopping Center. By the time this map was drawn, most of the rancho was out of the Welch family's hands; however, notice "Welch's House" at the south end.

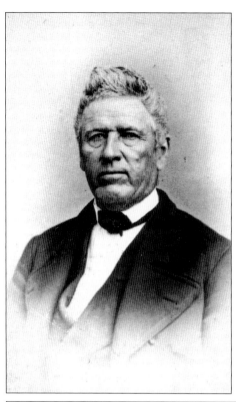

William Hook was born in Salem, Virginia, and made expeditions to the Southwest, trading and exploring on the Santa Fe Trail and the Mississippi River. William married Miranda Brown in Missouri in 1835 and came to California in 1850. The couple lived in the gold country before moving to Pleasant Hill in 1857. The Hooks were a prominent family in the area, owning several large parcels of land.

William and Miranda Hook's home was built in 1857 on their land near Hookston Road, east of today's Highway 680. The trees on the property reportedly produced abundant acorns, which the native people would gather.

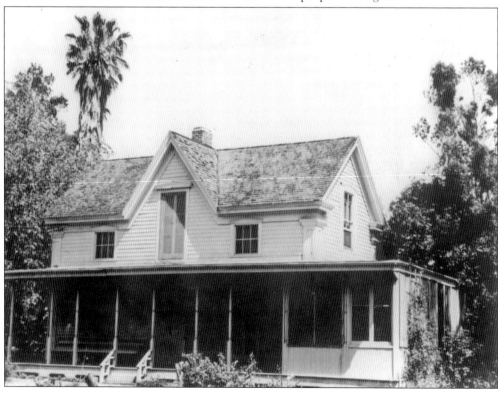

Four generations of a family with prominent local surnames are shown in this photograph, taken around 1892. Miranda Brown Hook (right), wife of William Hook, is pictured with her daughter Amanda Hook Brackett (left, wife of Rufus Brackett), granddaughter Grace Brackett Putnam (standing, wife of George Abram Putnam), and great-grandson George Blalock Putnam (future husband of Frances Vessing). (Courtesy James C. and Bobette Douglas.)

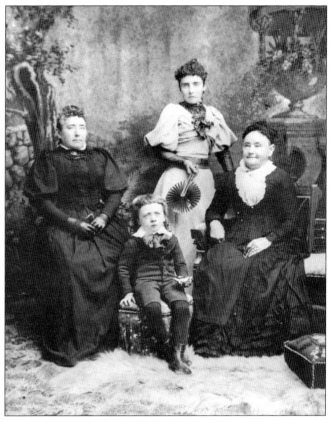

Vincent Hook, William and Miranda's son, moved into his parents' house with his wife, Adele Raap Hook. This interior view of the house shows the piano that Adele played.

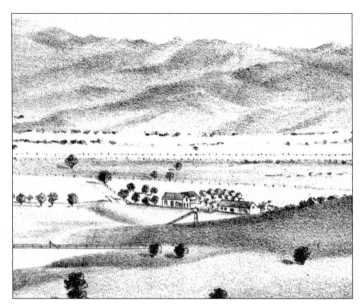

David and Martha Boss and their adult children migrated to the West with the Mormons who were expelled from Nauvoo, Illinois. In 1849, they arrived in California, where their son Alexander worked in the gold mines. The Bosses purchased land from the Welches, and the cluster of houses in this 1865 drawing probably stood near today's Pleasant Hill Road and Taylor Boulevard.

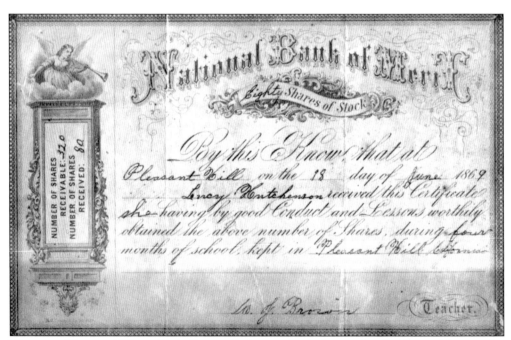

The name Pleasant Hill was likely first applied to a school, then to the district, and later to the area in general. It is known that a schoolhouse was built around 1865, at which time this certificate was issued, and that this structure also served as a place for community meetings. There may have been a school before this, as older residents stated in the 1950s. The original location of the 1865 school is unknown, but it was probably on a knoll south of David McClellan's house (see page 22), near today's intersection of Pleasant Hill and Huston Roads. Living within the school district in 1866 were 41 white and 3 "Indian" children between the ages of 5 and 15, and 24 students under 5. About 30 attended during the school's two-month session.

Charles Hazeltine bought 88.33 acres of land from William and Maria Welch's children—Juan, Vicente, Guadalupe, and Refujio—in 1854. On the map on page 22, this property lies south of the Hook land along the Arroyo de las Nueces. It is pictured here from across the Walnut Creek–Pacheco Highway, today's North Main Street. The Pleasant Hill BART station sits here today.

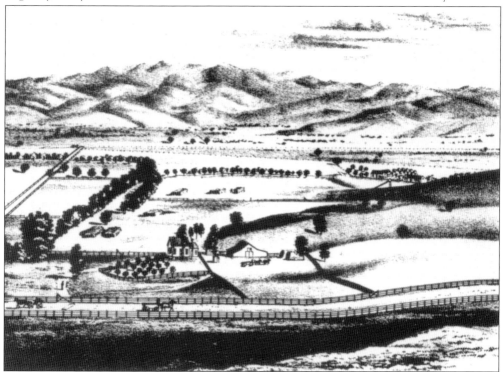

F. M. Warmcastle came to California in 1849 and served as a county judge and state legislator in the 1850s and 1860s. He purchased 250 acres and lived there with his wife, Catherine, until they conveyed the land to John and Dennis O'Keefe. This area, labeled "O'Keef" on the map on page 22, was later sold to the Roche family. The northern part became Diablo Valley College.

The California Gold Rush was what brought William Dukes and many other pioneer families to the area. Dukes traveled from Tennessee to California and worked as a miner at Bidwell's Bar in Placer County. He later built his house on Grayson Creek, near the intersection of today's Pleasant Hill Road and Taylor Boulevard on land that straddled the line between Rancho Las Juntas and Rancho Cañada del Hambre. His obituary praises him for having done "his bit in laying the foundation of this great western commonwealth."

Lucy Kinzer Dukes, William's wife, rode across the plains to California in a covered wagon, say her descendants. Her first husband was a member of the Boss family, and it is through this connection that she and William obtained their property.

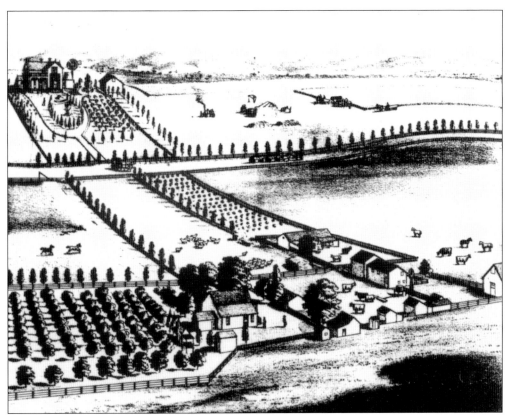

John Larkey was born in Ohio in 1831 and came to California in 1853. He purchased 730 acres in the area now bounded by Geary and San Luis Roads and the Walnut Creek. A horse breeder, he and his wife, Martha, lived with their children in the house pictured here, which was near today's Contra Costa Canal on the south side of Geary Road. One local recalls using the circular driveway as a racetrack in the 1960s, before the house was destroyed. The area was considered part of Pleasant Hill until Walnut Creek annexed it in the 1950s.

Pleasant Hill School's graduating class of 1881 included Alonzo Larkey, whose family's property was formerly part of the Pleasant Hill School District. Alonzo settled in Piedmont and worked as a physician, while his brother Ed remained on the Larkey ranch.

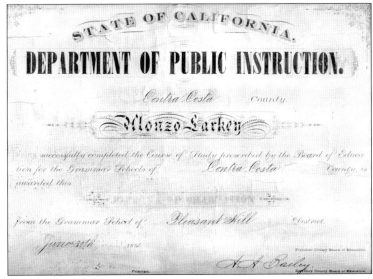

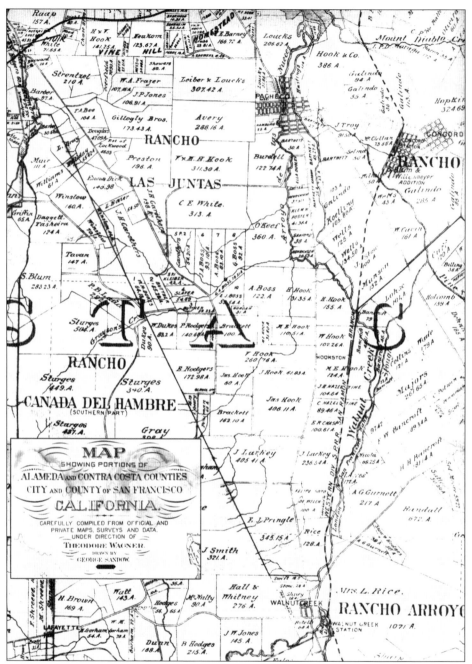

By the time this map was drawn in 1893, Rancho Las Juntas had been divided among many families. The 1892 schoolhouse is labeled at the site of the current "old schoolhouse," at the intersection of Pleasant Hill Road and Oak Park Boulevard on Edward Rodgers's property. Other landmarks are J. A. Boss's land, now Mangini Farm; V. and M. H. Hook's land, now the Contra Costa Country Club; and the Hookston flag stop on the Southern Pacific Railroad. These property divisions shaped Pleasant Hill's future layout as farmers sold their land in pieces to developers. It is no coincidence, for instance, that the shape of today's Grayson Woods Golf Course perfectly follows the diagonal layout of the J. H. Carothers land on which it was built.

Two
1900s–1910s

Slicing through the hills and valleys, Pleasant Hill's creeks were once the most prominent natural lines in the land. As seen in the last chapter, new settlers employed fences, boundary markers, and dirt roads as artificial lines to divide the land into neat sections. A third creation cut through the land in another way in the late 19th and early 20th centuries: the railroad. The Southern Pacific Railroad opened its San Ramon branch line in 1891. With its main route along the Carquinez Strait, the railroad's new branch ran south from nearby Martinez to the San Ramon junction on the Altamont line. The Oakland and Antioch Railway was created in 1911 to compete with the Southern Pacific; it later became the San Francisco–Sacramento Railway and then the Sacramento Northern.

These lines brought a new prosperity to the families in Pleasant Hill and the areas served by the railroad. Farmers used the railroad to sell and trade goods, further strengthening the local economy through networks of farm families. Schoolchildren could attend high school more easily by taking the inexpensive train to Mount Diablo High School in Concord. Eastern Pleasant Hill had three train stops on these two railroad lines located in close proximity to each other. The most prominent of these was Hookston, where the train facilitated trade and around which the first trace of industry cropped up: a winery. Hookston was not a downtown by any means, but rather a nucleus around which further growth would occur.

During this period, Pleasant Hill was still betwixt and between the larger communities of Pacheco, Martinez, Concord, and Walnut Creek. The railroad—and the emerging automobile—linked residents to other communities, but Pleasant Hill remained somewhat of a blurry area between the larger towns. In this chapter are accounts of the agricultural community that influenced the future of Pleasant Hill by toying with property lines and riding transportation lines.

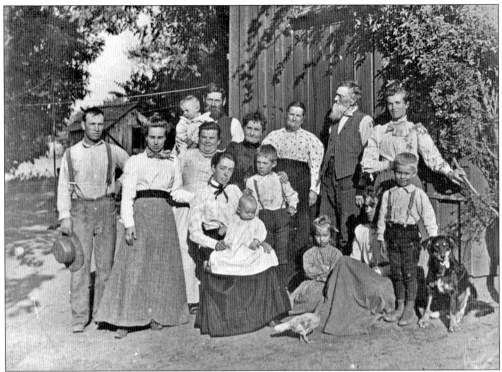

Members of the Dukes family pose on the family's property around 1900. Lucy and William Dukes are third and second from the right in back. Their son Sherard is at left, and sitting with the baby on her lap is his wife, Ida. The other individuals pictured are unknown.

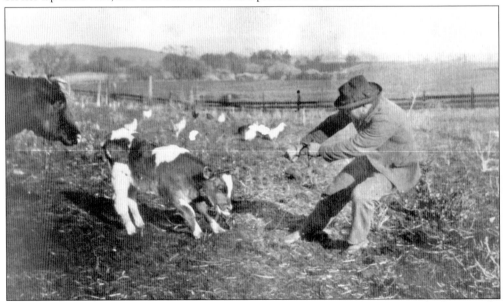

Sherard Dukes, shown here wrangling a calf, was an avid photographer. He took photographs with a box camera and developed them in the darkroom he built in his basement. Many of the images representing farm life in Pleasant Hill in the early 20th century were created by Sherard. (Courtesy Barbara Herbert.)

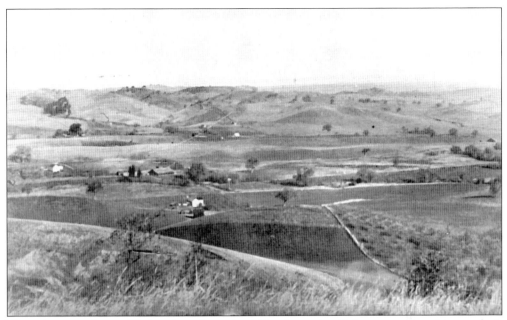

This photograph was likely taken from the hills above the Dukes property, above today's Taylor Boulevard and Grayson Road. The hill in the foreground with the fence appears to be Dinosaur Hill. The view likely shows parts of the Boss family's land, and the buildings near the image's center bear a resemblance to those sketched on page 18.

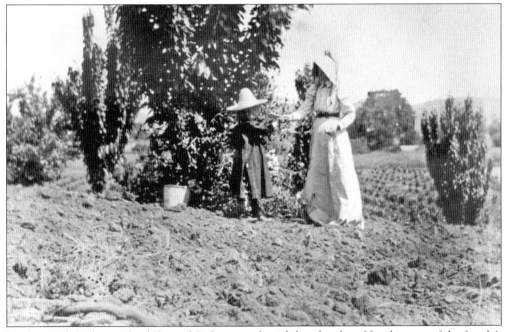

Ida Symonds Dukes, wife of Sherard Dukes, stands with her daughter Hazel in one of the family's orchards. Ida's family, who had also come to California during the Gold Rush, lived mainly in San Francisco and Petaluma before moving to Martinez in 1891. According to Ida's great-granddaughter, Barbara Herbert, it was always a big and exciting event when the family's city relatives would visit their kin in rural Pleasant Hill.

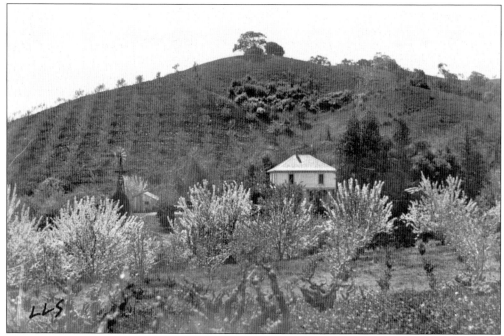

The Dukes home is the "heritage" of Heritage Hills Drive, which now runs up this hill off Grayson Road. Walnut trees were extremely abundant around the Dukes property and all over the Pleasant Hill area. Barbara Herbert remembers that later, in the 1940s, some local families hired gypsies to harvest their walnuts. Barbara's parents warned her to stay away from the camps that the nomads set up among the walnut trees. (Courtesy CCCHS.)

In January 1913, some parts of California saw temperatures of 10 to 15 degrees Fahrenheit, which brought snow to Pleasant Hill. This photograph most likely shows the Dukes property. The damage to California fruit led the U.S. Weather Bureau to establish a fruit frost forecast program.

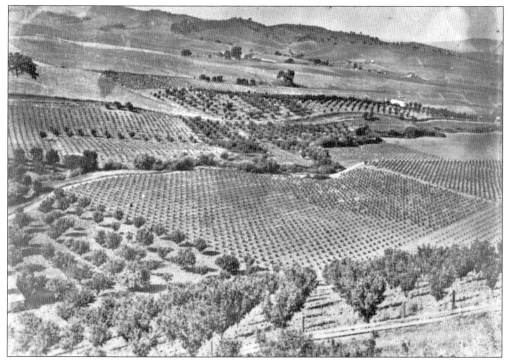

This photograph, probably taken slightly later and farther north than the one on page 25, reveals a patchwork of orchards and vineyards belonging to the Dukes, Buttner, and Slater families. The land is crossed by the tree-lined Grayson Creek, and the road below the tree in the upper left corner is likely Grayson Road. Pleasant Hill Road (today's Alhambra Avenue) would run near the base of the hills in the background.

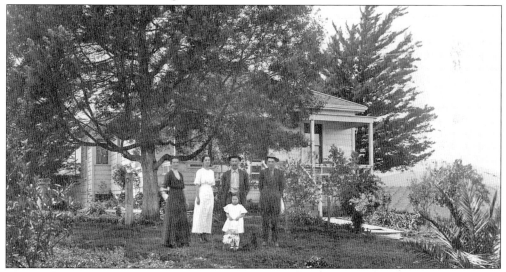

Clara Belle Boss Slater (left), granddaughter of David Boss, is pictured around 1912 with her daughters Edna (second from left) and Bernice (in front); her husband, James (second from right); and an unidentified man. This house was originally located on a hill on Pleasant Hill Road but was moved to a lower place on the west side of the road. It still stands there, just north of Strand Avenue. (Courtesy Karen O'Neill, Jill Hendrick, and Susan Kilpatrick—granddaughters of Edna Slater.)

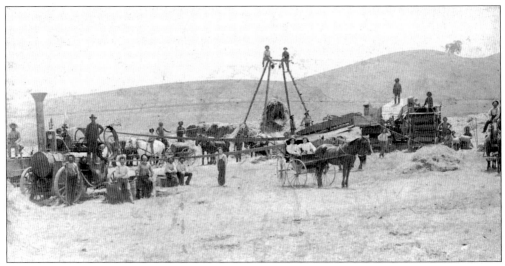

A work scene at what is presumed to be the Dukes ranch shows the volume of people and the complexity of the machinery required for farming tasks. The men with the horse and wagon to the right are bringing bundles of grain to the thresher, the large piece of machinery next to them. This machine separated the grain from the straw, which was moved to the tower contraption to be made into bales. The steam engine at the far left powered the thresher using a long belt; the long distance was intended to keep engine sparks from igniting the straw from the thresher. The ladies in the buggy are the only two whose names are labeled: "Aunt Nan" and "Aunt Lill," probably Annie Rodgers and Catherine Rodgers Kramer (see page 31). (Courtesy FORR.)

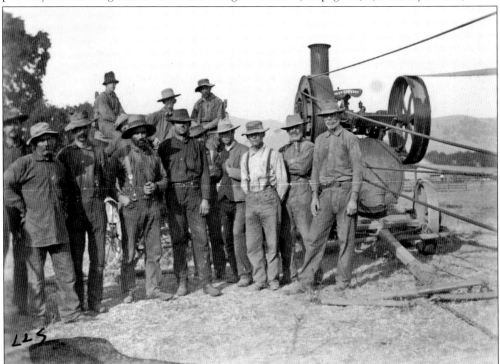

Neighbors often helped out by working in crews on each other's farms. This 1901 photograph shows a crew from the Dukes and Buttner families in front of a steam thresher. (Courtesy CCCHS.)

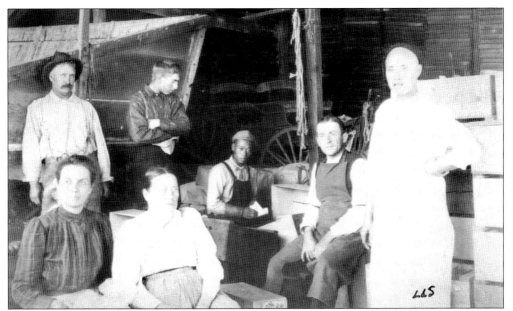

James Hook (son of William Hook) and his son Theodore stand behind James's wife, Louise, and a Mrs. Pence. A Chinese man named Jin, the family's cook, stands to the right of two other unidentified workers. Theodore Hook, quoted in a 1959 issue of the *Contra Costa Gazette*, said of the ranch hands, "We all had breakfast and lunch together and I remember that we had a Chinese cook when I was a boy. He was a dandy. Our family had dinner later than the men in the smaller dining room. The cook would fix up some fancy desserts for us sometimes, but otherwise the food was the same as the men had." (Courtesy CCCHS.)

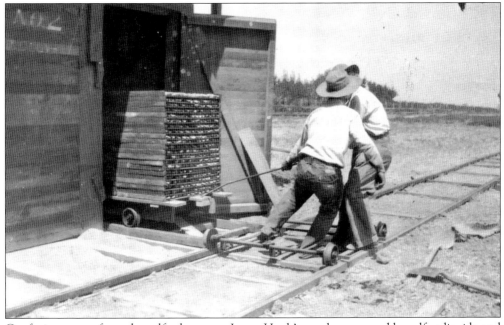

Cut fruit emerges from the sulfur house on James Hook's ranch, preserved by sulfur dioxide and prepared for drying. These products were most likely pears, one of the most commonly grown fruits in the area. Hook sold almost 400 tons annually. (Courtesy CCCHS.)

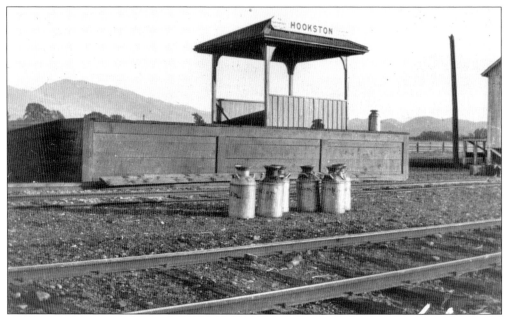

An early name for the area was Hookston, named for the Hook family. The Hookston stop on the Southern Pacific Railroad was a flag stop, meaning that the train did not make scheduled stops; it only stopped to let passengers off or pick up those who flagged down the train. Farmers would also leave their products, like these milk cans marked "Hookston," at the stop to be picked up and sold at market, thereby widening agricultural networks and strengthening the local economy. (Courtesy CCCHS.)

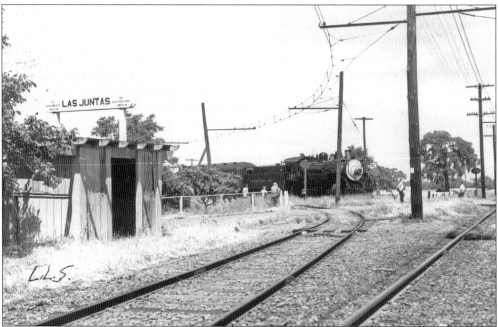

One of Sacramento Northern's electric interurban trains arrives at Las Juntas station, where the Southern Pacific and the Sacramento Northern Railroads crossed. This crossing was located where the BART trains pass over Coggins Drive today. (Courtesy CCCHS.)

The California Wine Association constructed a winery on Vincent Hook's land in 1903. The buildings are to the left of Theodore Hook, who is seen crossing the tracks near the Hookston flag stop. The association formed in 1894 to stabilize wine prices and quality in response to poor wine and over-productive vineyards. Until 1920, when the winery closed due to Prohibition, growers would bring their grapes to this facility, which could hold 700 tons. (Courtesy CCCHS.)

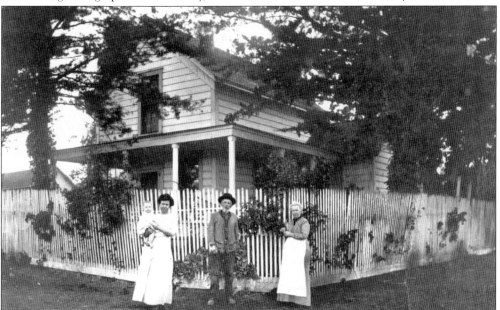

Brothers Edward and Patrick Rodgers were born in Ireland and immigrated to California about 1851. As gold miners, they owned claims near Columbia in Tuolumne County. They came to Pleasant Hill around 1868, and their adjacent properties can be seen on page 22. In this photograph, Edward and his wife, Letitia, stand to the right of their daughter Catherine, who holds her son Stanley Kramer. Edward and Letitia's son Frank kept his farm until his death in 1971; by the time he died, he had sold most of it for the construction of the Hillsdale subdivision in the Pleasant Hill Road/Hamilton Drive area.

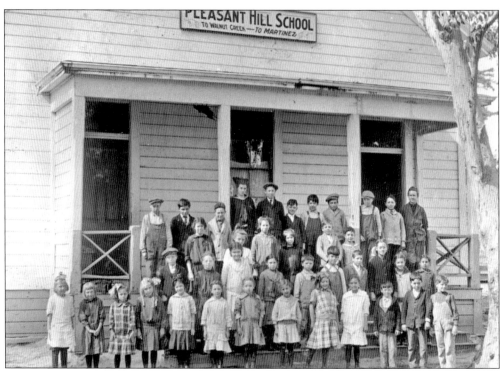

The third known Pleasant Hill School was built in 1912 on the Vessing property on Murderer's Creek. It was likely situated just south of today's "old schoolhouse," between Oak Park Boulevard and Geary Road.

Dan Baldwin both designed and drove the first school bus to Pleasant Hill School in the 1920s. He built a frame to hold a canvas enclosure over his flatbed truck, which, after he transported the local children to school, he could easily remove to make the truck available for farm use. Baldwin was mayor of Concord from 1926 to 1929.

A well was the only source of water for the 1912 schoolhouse, and the surrounding eucalyptus trees had a habit of clogging the well and consuming the water for themselves. An addition was constructed on the right of the building, and when the school closed, members of the Vessing family are said to have used pieces of the addition to build a house that still stands on Vessing Road. (Courtesy Barbara Herbert.)

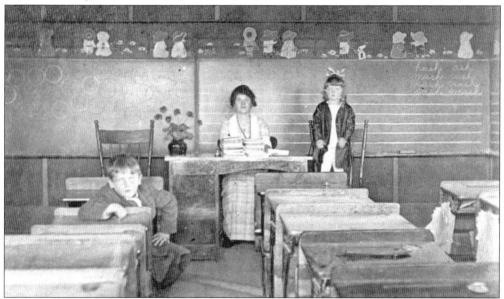

Teacher Charlotte Boyd rode a horse-and-buggy from Concord to this classroom at the Pleasant Hill School, sometimes with great difficulty. Though the unpaved road was scraped even especially for her trip, she was sometimes still unable to show up. Pictured here with two younger cousins, Charlotte was the daughter of Joseph Boyd, the first mayor of Concord, for whom Boyd Road was named.

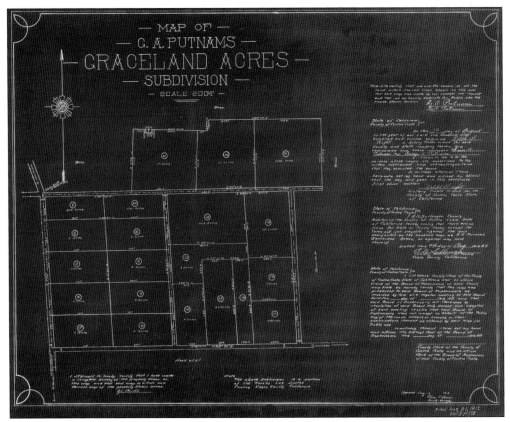

Following the 1906 earthquake, hordes moved from San Francisco to the East Bay. Real estate companies offered free train rides to the Contra Coats area to showcase "profit and independence in a five acre farm for the city man," as a 1912 brochure for Concord promised. George Abram Putnam and his wife, Grace Brackett Putnam, created the first Pleasant Hill subdivision from their land in 1912. Calling it Graceland Acres, the Putnams carved 110 acres into 21 suburban farms (or "ranchettes") for public sale. The vertical roads on this blueprint are Pleasant Hill Road, Brandon Road, and Kahrs Avenue; Gregory Lane is the horizontal road above Boyd Road.

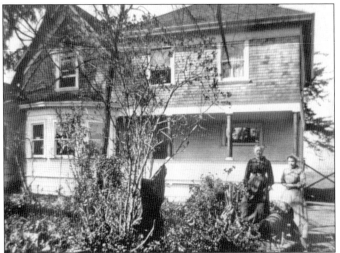

Amanda Hook Brackett and daughter Grace Brackett Putnam stand in front of the Putnam house, on today's Belle Avenue. One day when Grace was riding a train on the Key System, an early Bay Area transit system, she encountered a man with eucalyptus seeds from Australia. She planted one of them behind this house, and although the house is gone, the resulting tree remains.

Amanda Hook Brackett and her great-granddaughter Claire Putnam Douglas stand on the porch of the family's home on Oak Park Lane. George Blalock Putnam, Claire's father, built the house using locally milled redwood about 1910.

Members of the Vessing family and other locals attend a Fourth of July picnic around 1915. Families frequently spent leisurely days in areas like Franklin Canyon, Morgan Territory, or Mount Diablo. Fresh air and the outdoors started attracting people to Pleasant Hill early on; in fact, a doctor in New York directed the patriarch of the Vessing family, Enoch Vessing, to move to California to improve his bronchitis. Enoch bought his Pleasant Hill property in 1902. (Courtesy Yvonne Clark.)

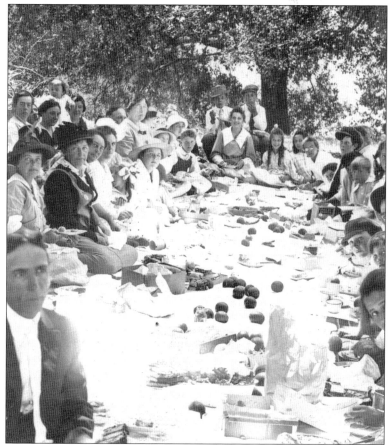

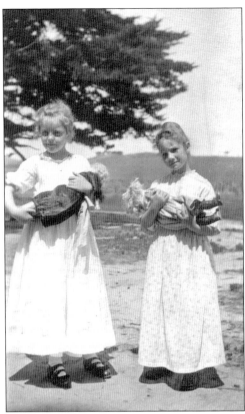

Relatives Dorothy Putnam and Ardene Vessing display their miniature friends on Doll's Day in 1915, an event organized by the school. (Courtesy Yvonne Clark.)

In 1891, Frank Rodgers helped move the 1865 schoolhouse from its original location to property owned by his father, Edward, for use as a granary. Here Frank's wife, Kate, and his daughter Winifred are pictured in front of the granary, which is to the left. Relatives recall that the building was located off Pleasant Hill Road near the Pacific Gas and Electric substation, across from Wood Creek Place.

Three

1920s–1930s

Though previous schoolhouses had been meeting places for Pleasant Hill residents, the 1920 schoolhouse had a more significant role in strengthening local identity. Former student Stanley Kramer called it one of few "country schools" with an auditorium especially for social events like pageants, parties, and movies. The school could be rented at a cost of $15 for a social event or $3.50 for a church event or community benefit.

The school's function as a social center, combined with the increasing use of automobiles, made it a place for locals to fortify relationships with each other. In earlier years, families had little interaction with people other than neighbors and those with whom they did business. In this era, more and more parents started driving their children to school, according to former student Elmer Filomeo. The schoolhouse, thus, brought together families from far corners of the district, expanding both parents' and children's social circles.

Another center of the growing community, the Soldiers' Monument, appeared in 1927 and served a slightly different function. While the new school bolstered locals' identity with the Pleasant Hill community, the monument bolstered outsiders' recognition of Pleasant Hill as a community. When the monument was built, the instant landmark made Pleasant Hill no longer an abstract and unrecognizable area between larger towns. In addition, the appearance of a monthly "Pleasant Hill Notes" column in the *Contra Costa Gazette* demonstrated to readers that Pleasant Hill was, indeed, its own entity.

As older folks died, their heirs divided large parcels of land into increasingly smaller pieces and often sold property to newcomers. New families, many of them Italian, settled in the area around this time. In the late 1920s, the Great Depression affected locals differently, and some found that they could not support themselves by farming. Thus, at the same time that locals were reinforcing Pleasant Hill's identity as a community, waves of arrivals and departures brought new flows of people who contributed different elements to the community.

The fourth schoolhouse opened in 1920 on the same land as the second schoolhouse, which had been built in 1892 on Edward Rodgers's property. The 1920 school is shown here in 1936. As an adult, Stanley Kramer (the baby on page 31) described some impressive features of the new school: separate lavatories for boys and girls, a kitchen for mothers to prepare potato soup on cold days, and a gas-powered pump that drew well water into the water tower visible in this photograph. In 1921, the schoolhouse received electricity.

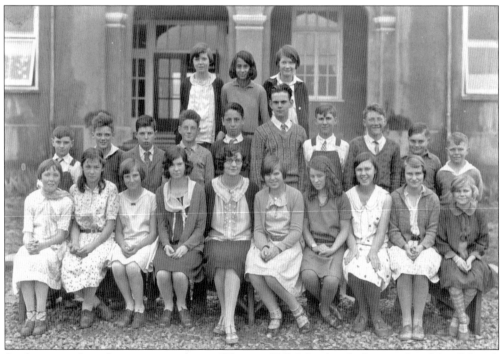

Students pose for a class portrait in front of Pleasant Hill School with their teacher, Mrs. Gilman, in 1928. The parents of Richard Cuendett (second row, third from left), Philip and Rose, emigrated from Switzerland and tried their hand at farming in Pleasant Hill. They were among the families who had to sell their land during the Great Depression; the family moved to Oakland, where Philip worked in shipbuilding.

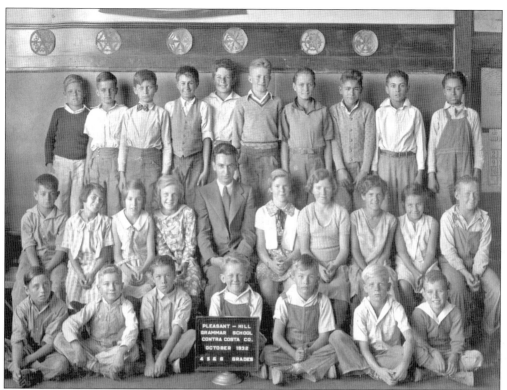

The fourth-, fifth-, and sixth-grade classes of 1932 are pictured inside Pleasant Hill School. Their teacher, Arthur Harris, was the first male teacher at the school.

The alleged pleasant hill is the backdrop for this 1934 photograph of Pleasant Hill schoolgirls and two teachers. Taken in front of the school and looking west, this view shows a car rounding the bend onto Oak Park Boulevard from Locust Way. This same year, Locust Way, named for a Lafayette farm covered with locust trees, was changed to Pleasant Hill Road.

In the late 1920s, the pastureland near the schoolhouse was dragged smooth and a wire backstop erected. According to Stanley Kramer, a quarter-mile oval track was also created. Student athletes had to be careful not to step in cow manure, or "'dobe clods," while training there for the county track meet at Mount Diablo High School.

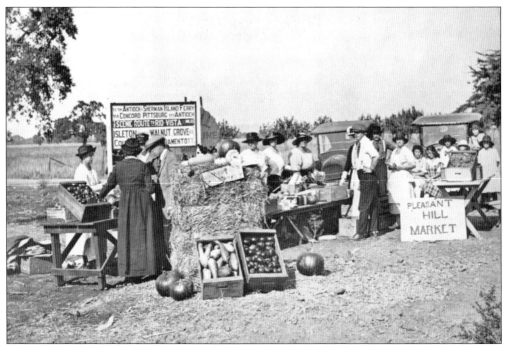

Ida Symonds Dukes (far left), a founding member of the Parent-Teacher Association, was responsible for publicizing the Pleasant Hill Market and obtaining a permit for the grounds on which the market was held.

Students and their teacher, Mr. Harris, celebrate graduation around 1932. Other formal events included parties for upper-class students to learn politeness and etiquette.

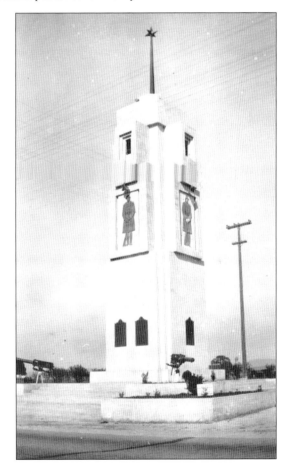

Built in 1927 after a decade of fundraising, the Soldiers' Monument was meant as a memorial to the soldiers who had died in World War I. Pictured in its original location at Hookston Place (the intersection of Monument and Contra Costa Boulevards), it stood on a triangle in the middle of the intersection (as seen on page 64). It was moved in 1954 to allow for road expansion and placed at the corner of Boyd Road and the Contra Costa Highway. (Courtesy CCCHS.)

Italians Peter and Emilia Molino, Italian immigrants from Asti and Torino respectively, purchased land at the southeast corner of Pleasant Hill and Boyd Roads and had an Italian-style house custom designed around 1925. Their daughter-in-law Margherita Molino recalls how proud Peter and Emilia were of the home, which is currently under renovation. (Courtesy Margherita Molino.)

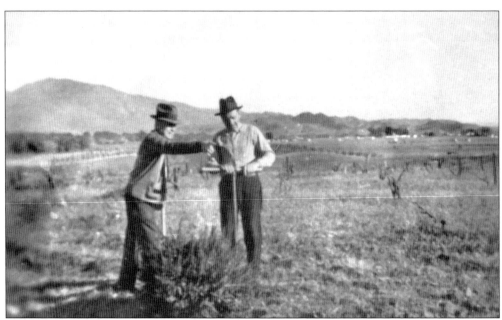

Peter Molino (left) and a friend work on the new vineyard surrounding the Molino home with Mount Diablo in the background. Peter and Emilia's son, also named Peter, was born in a brown shingle house near the intersection of Pleasant Hill and Grayson Roads, but the family lived most of the time in Emeryville at first. There they owned and operated the Powell Street Café, where Emilia served 500 people every day for lunch. They stayed in Pleasant Hill only on weekends until they moved there full-time in the 1950s. (Courtesy Margherita Molino.)

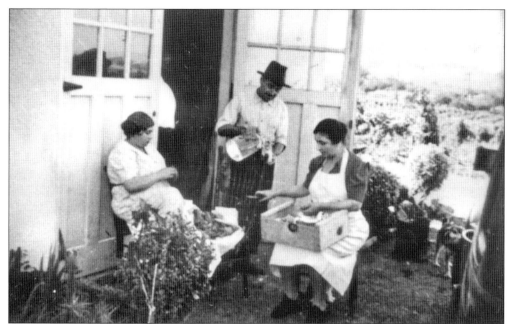

"They were raised in the peasant style and they never, ever outgrew it," says Margherita Molino, describing the work ethic of her husband's family. They grew produce that they used in their café, including tomatoes, which they churned and used for sauce. Here Emilia (right) peels potatoes with two friends while her husband stands partially hidden in the doorway to the wine cellar. Among the families in the area, including the Manginis, it was agreed that the soil on the Molinos' land was the best for growing grapes and produced the best wine. (Courtesy Margherita Molino.)

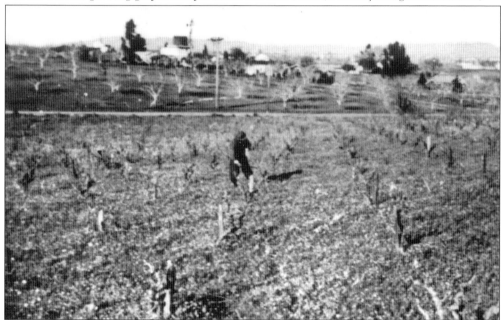

The Molinos' vineyard undergoes maintenance, with Pleasant Hill Road and the pear trees of the former Patrick Rodgers property in the background. While the Molinos lived in Emeryville, the Mangini family took care of the Molino land in return for goods. (Courtesy Margherita Molino.)

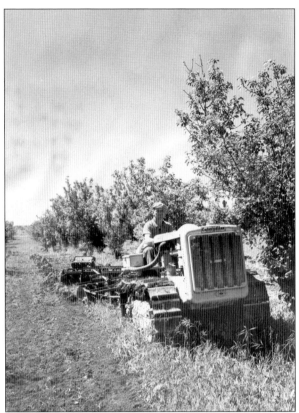

Fernando and Emma Delu came from Asti, Italy, to Oakland, where they ran a boardinghouse before moving to Pleasant Hill a few years later. On their land, which is to this day adjacent to the Mangini property, they grew walnuts, pears, and mission grapes, as well as other fruits. Their son Louis is pictured "disking" the land, breaking up the orchard soil as part of springtime upkeep. Fernando was able to live almost entirely off the land, but Louis got a full-time job at the refinery and worked the land in the evenings and on weekends. (Courtesy Daniel Delu.)

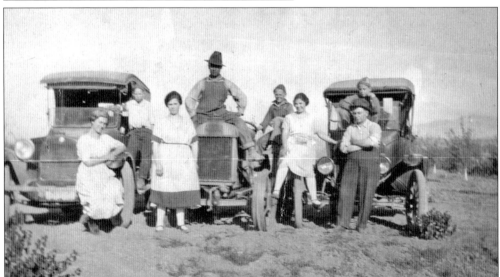

Members of the Delu family (Fernando at front right with arms crossed) are shown with their Dodge panel truck, Fordson tractor, and Model T around 1915. The Delu family was distantly related to the Bertana family, members of which may also be in this image. The two families lived near each other both in Italy and in Pleasant Hill. Felix and Mary Bertana's land was located two lots east of the Delus' property, roughly between Taylor Boulevard and Westover Drive, where Mercury Way and Vineyard Court are today. (Courtesy Emil Bertana.)

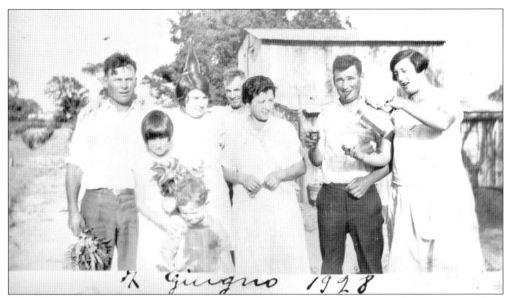

Felix (left) and Mary Bertana (next to him with an arm around his shoulder) pose near their barn with their Pleasant Hill friends, the Beltramos, and cousins from Crockett in 1928. At first, the Bertanas only sold the grapes from their abundant vineyards, but during Prohibition, they opened a winery on their property. This was allowed under certain conditions: Felix had to put bars on the windows of the winery, keep the door locked at all times, and replace screws with heavy-duty bolts. Because of this "red tape," he closed the winery after two years and started selling the grapes again. (Courtesy Emil Bertana.)

Mary Bertana is pictured in the vineyard with her infant son Emil and a nephew in 1929. Emil remembers when the revenuers would come to inspect his family's winery. His father, Felix, would say, "Go in the house with your mother," and answer the revenuers' questions. They knocked on every barrel in the cellar and inspected the contents to ensure it was only wine. Within a one-mile radius there were a handful of people making moonshine; Felix would always direct the revenuers there to get them out of his hair, but the moonshiners would direct them right back. (Courtesy Emil Bertana.)

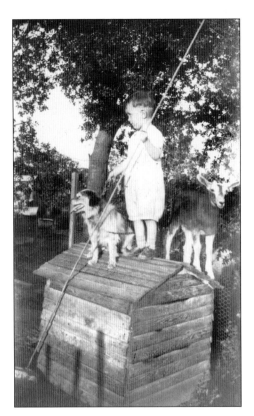

Emil Bertana shares the doghouse roof with its inhabitant, Paddy the dog, and a goat in 1931. (Courtesy Emil Bertana.)

The tank on the Bertanas' property could hold 10,000 gallons of drinking water, drawn from a well by a windmill and piped into the house. The Bertanas would have to climb up the ladder to see how full the tank was and either start or stop the windmill as necessary. Emil Bertana recalls when surveyors came to the ranch "looking all over the place" to decide where to build the Contra Costa Canal. Completed in 1948, it brought much-needed irrigation water from the Sacramento River Delta, and the trail that follows it is now a popular recreation area. The Bertanas' barn, shown on the previous page, was approximately 75 feet from the canal. (Courtesy Emil Bertana.)

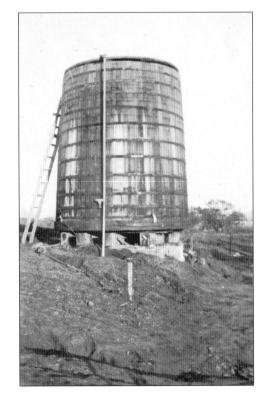

Members of the Mangini family have lived in Pleasant Hill since the late 1800s. Mario and Anna Mangini came from Genoa, Italy, and bought a piece of land east of Pleasant Hill Road and north of Grayson Creek from a Native American at a court auction. Their sons, Gene (left) and Louis (center) pose with Emil Bertana around 1934. The Manginis grew pears, prunes, peaches, and grapes, and at one point their property was covered with walnut trees. (Courtesy Emil Bertana.)

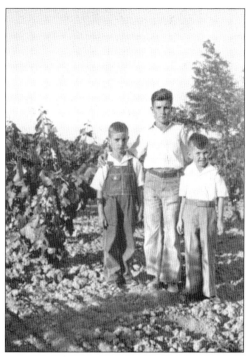

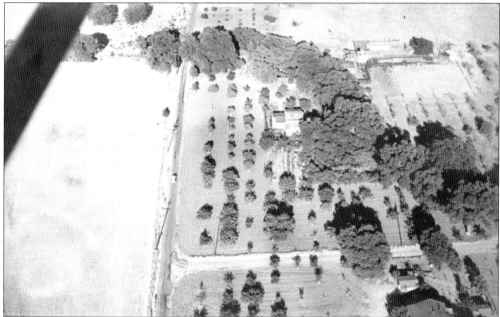

Running vertically in this 1939 photograph of the Putnam property is Oak Park Boulevard, with Oak Park Lane perpendicular to it at the bottom. The Contra Costa Canal parallels this lane today. The family of George Blalock Putnam lived in the house on Oak Park Lane (pictured on page 35) until 1935, when he built the white stucco house near the center of this image. His daughter Claire and her husband, William Eagles Douglas, raised their family here; the nearby Douglas Lane is named for them. The tree on Murderer's Creek, just right of Oak Park, is one of several that have been called Hangman's Tree. (Courtesy James C. and Bobette Douglas.)

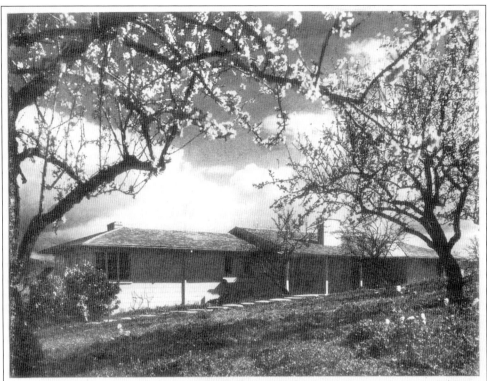

Author's home. The house and site are in perfect harmony. The Chinese symbol for man and wife adorns the entrance-porch chimney

 # EAST MEETS WEST

HERE'S THE EXCEPTION to the poetic rule that "East is East and West is West, and never the twain shall meet." On first glance, it's a pleasant ranch house in an apricot orchard in Walnut Creek, Calif. But step inside, and you'll find its spirit comes from China. It's the home that Architect Harry A. Bruno planned for Mr. and Mrs. Earl T. Hobart. Mrs. Hobart—better known as Alice Tisdale Hobart—is author of *Oil for the Lamps of China*. During many years in the Orient, the Hobarts collected art treasures and furnishings that now grace their California home. See how admirably the plan meets the needs of a person who's able to combine home and workshop. Note too the provisions for informal country living.

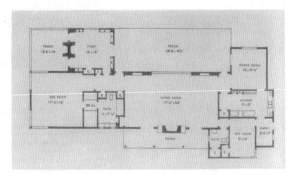

24 SUNSET

The May 1939 issue of *Sunset* magazine featured an innovative house on Patrick Rodgers's former ranch. Author Alice Hobart and her husband, Earl, bought the property in 1937. Here Alice wrote *The Cup and the Sword*, which was made into the movie *This Earth Is Mine*, starring Rock Hudson. The article gives the location as Walnut Creek, although the ranch was in fact in the more obscure Pleasant Hill. The ranch also received media attention in 1915, when the Luther Burbank Company eyed it for a possible demonstration farm for its "exceptional soil" and climate; financial issues prevented this from happening. (Courtesy Sunset Publishing Corporation.)

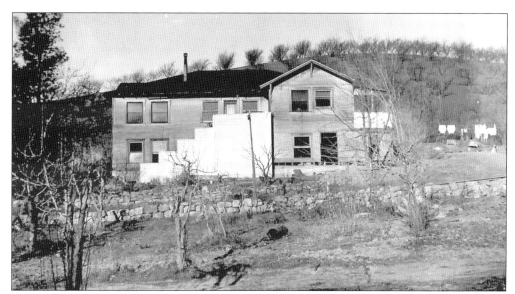

Antone and Sara Filomeo, natives of Calabria, Italy, lived in San Francisco, Vacaville, and Oakland before buying 100 acres in Martinez in 1920. Their land, stretching between Alhambra and Morello Avenues along today's Elderwood Drive, became part of the Pleasant Hill School District in 1937 and ultimately part of the City of Pleasant Hill. Apricot trees grew at the top of the hill, and peach trees flourished in front, where Elderwood Drive now runs. (Courtesy Vivian Cannelora.)

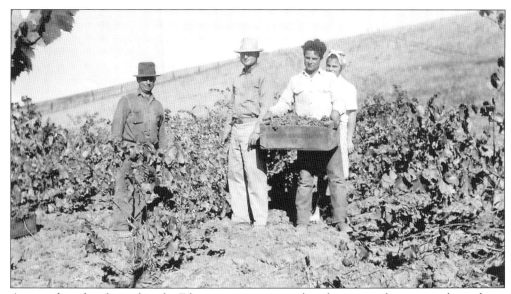

Among the other fruits that the Filomeos grew were apples, cherries, and grapes, as shown here. During the summer, the family would cut the fruit in a special cutting shed, lay it on trays, leave it overnight in a sulfur house after lighting a sulfur fire, and remove the fruit to dry in an open area called the dry yard. They would put the dried fruit in sacks and deliver it to customers in Oakland. (Courtesy Vivian Cannelora.)

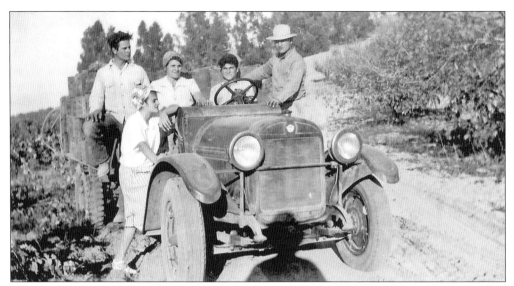

After picking grapes, the Filomeos used a wine press to extract the juice, which they sold in barrels. Vivian Filomeo Cannelora (front), Antone and Sara's granddaughter, remembers making deliveries with her father, driving through the one-lane tunnel to Oakland and onto the ferry to San Francisco before the Bay Bridge was built. (Courtesy Vivian Cannelora.)

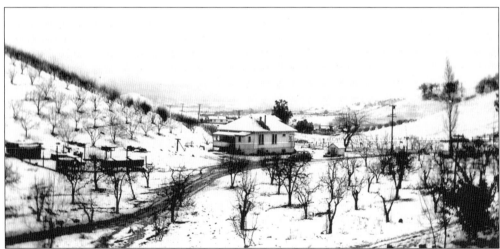

A snowfall deep enough for making snowballs blankets the Filomeo property in 1937. In this photograph, the telephone poles along Alhambra Avenue, then called Pleasant Hill Road, are visible. The Filomeos took this road to Martinez, where they bought staples like flour and sugar. Otherwise, they were mostly self-sufficient; they had a vegetable garden and kept hogs, chickens, turkeys, and a cow for milk. They also bought bread, which was delivered to the house. During the Depression, "Nobody had much money," says Vivian Filomeo Cannelora, "but people on farms were better off." (Courtesy Vivian Cannelora.)

Four
1940s–1950s

"Aerial Proof of Phenomenal Growth," heralded the *Pleasant Hill News* on April 8, 1954, showing an aerial photograph of a mosaic of houses surrounded by orchards and fields. As if Pleasant Hill residents needed a photograph to prove the growth that the community had undergone, the caption goes on to muse about the population of 20,000 in an area that "before the war was a scattering of a few farm houses." Following World War II, the influx of young families and their baby boom offspring brought great changes to the landscape and identity of Pleasant Hill.

Unlike most prewar subdivisions, the new developments comprised land lots of less than one acre, organized to fit like puzzle pieces along curving lanes with houses built in a handful of designs. Among the first of these were Pleasant Acres (the Patterson Boulevard/Soule Avenue area) and Pleasant View Homes (now called Poet's Corner), both constructed in 1946. Land maps of the period reflect a blend of old and new landholdings—broad swaths of agricultural land next to tightly packed subdivisions. Until neighboring ranchers sold their land to developers, many of the subdivisions remained suburban islands in a rural sea.

Businesses developed along similar lines. The first businesses centered around Contra Costa Highway and Monument Boulevard in the early 1940s, but new shopping centers promoted the delights of one-stop shopping in disparate places away from the initial core area. As a result, many small centers emerged instead of one central downtown shopping area.

The 1950s wrapped up with intense discussions about the future of Pleasant Hill's identity. Residents of the new suburb had established a newspaper, schools, and numerous organizations bearing the name Pleasant Hill, bolstering its recognition as a community distinct from the surrounding cities. Still, ambiguity remained as people continued to receive their mail through other cities' post offices, and these cities began annexing Pleasant Hill's unincorporated land. A vote at the end of this period would be a crucial step in eliminating this ambiguity and establishing Pleasant Hill as its own incorporated entity in the decade to follow.

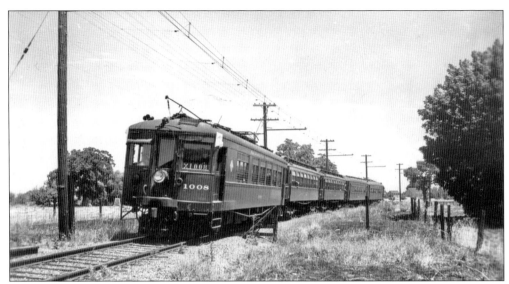

Mr. Knoblock, or "Knobby," was the conductor of the Sacramento Northern train that took students to Mount Diablo High School in Concord before Pleasant Hill had its own high school. Roberta Gardiner has fond memories of Knobby as "a father figure to all the students." This photograph shows the train near the Pleasant Hill stop in 1940, a year before the railroad ceased passenger service on this line. The economic prosperity that the railroad brought became its own downfall: more people able to buy cars meant fewer people riding the train. The tracks were used for freight service until 1958, and the right-of-way from Walnut Creek to North Concord later became the BART route. (Courtesy Paul C. Trimble Collection.)

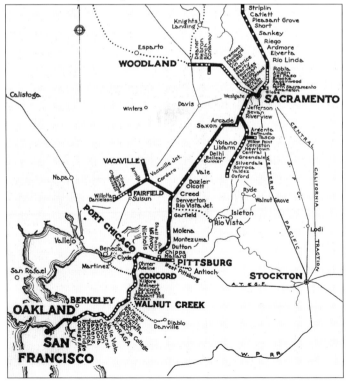

This map of the Sacramento Northern reveals the flag stop at Pleasant Hill. A stop not shown on this map, but mentioned on a 1939 timetable, is Sparkle. A comparison with other maps suggests that Sparkle and Pleasant Hill were one and the same. Some believe the name originated with the proximity to the Sacramento Northern's crossing with the Southern Pacific at Las Juntas. Electric trains going over this "diamond," as such crossings are called, may have produced sparks, or the name could play on the sparkle of a diamond. (Courtesy Paul C. Trimble Collection.)

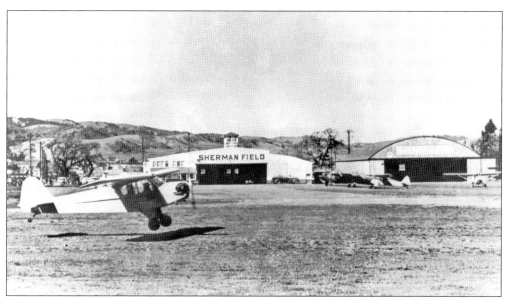

On May 11, 1941, Sherman Field opened as an airport and flying school on the east side of Contra Costa Highway, straddling Monument Boulevard. Eight lucky attendees at the opening ceremony won a drawing for a free airplane ride. After World War II, it operated as a civilian airport until closing in 1950. Hershul and Bernice Stephens moved their trailer home to Sherman Field in 1943, when Hershul was hired as an aircraft inspector. Bernice recalls sewing the fabric to cover the airplanes, and the couple also served as night watch guards.

Roberta Gardiner, who rode a pony to attend Pleasant Hill School as a child, bought this house with her husband in 1945 for $5,900. The C and H Sugar Company developed the Contra Costa Country Club in 1918 and moved this house, along with several others, to the creek behind the golf course. Known as "sugar shacks," the houses provided weekend lodging for company executives. Most of the sugar shacks have been modified, but Roberta still lives in her house in this tightly knit community just outside the city limits. (Courtesy Roberta Gardiner.)

Barbara Kutz Herbert, great-granddaughter of William Dukes, strolls near her family's land on a walnut tree–lined Grayson Road in 1940. Of note in this view, looking east toward what is now Taylor Boulevard, are the telephone poles alongside the road. The Kutzes, like many other local families, were part of a rural telephone line. Theirs was 6F, with the F standing for "farm." When a call was made to someone on 6F, every telephone on that line would ring. The Kutzes's number was 6F 2-1, meaning that calls to them were signaled by two long rings and one short. (Courtesy Barbara Herbert.)

Sherard and Ida Dukes stand outside their hilltop house off Grayson Road in 1945. Behind the screen was an icebox, which they continued to use even after they got an electric refrigerator. Barbara Herbert remembers her grandfather Sherard looking east from the hill and predicting, "One day, this valley will be filled with people." She recalls her family's puzzlement when the Strand Avenue area was developed on what the old-timers thought was terrible land, where water was known to stagnate all winter long. (Courtesy Barbara Herbert.)

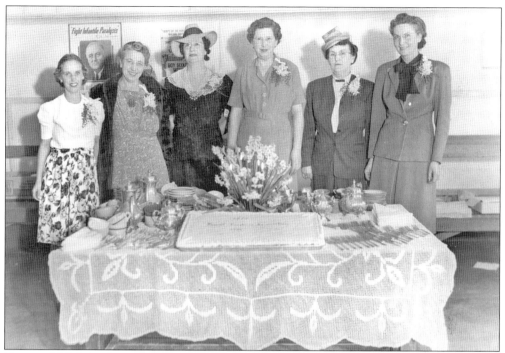

Pleasant Hill School principal Irene Spencer (right) poses with past presidents of the PTA for a Founders Day program and tea in 1946. Third from the left is Frances Vessing Putnam, wife of George Blalock Putnam and mother of Claire Putnam (pictured on page 35).

This photograph shows the backstop, playground, and water tower that stood to the west of the schoolhouse in 1941. Of note in this photograph is Alice Kawauchi (at right, holding the baseball bat). Several longtime residents remember that Japanese families lived on the east side of Contra Costa Highway, near today's Sun Valley Mall, and grew tomatoes there. Barbara Herbert recalls her father's indignation when these Japanese families were sent to internment camps in 1941.

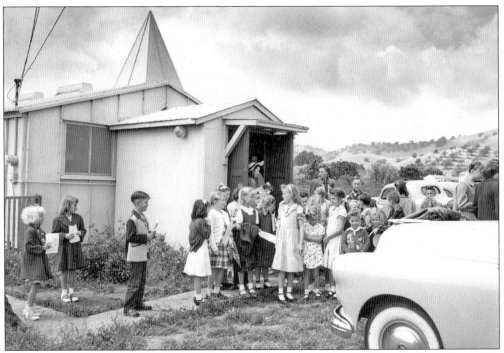
The residents' first church was the Pleasant Hill Community Baptist Church, located on Oak Park Boulevard near Pleasant Hill Road. Before the building opened in 1947, the congregation's Bible study classes were held in cars.

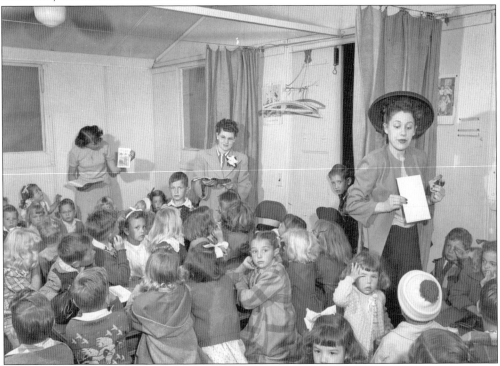
Children participate in a Sunday school exercise at the Baptist church in 1949.

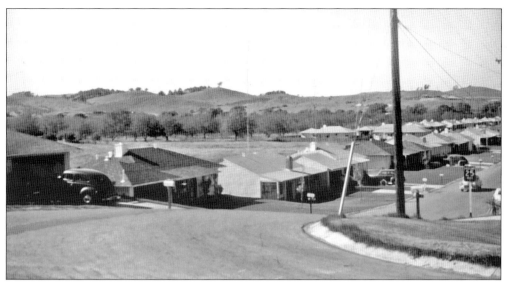

On December 3, 1949, Barbara Johnson and her husband became the first to move into the new Gregory Gardens housing development. Tired of cold weather at their San Pablo home, they were visiting Contra Costa and happened upon the model homes on Elinora Drive. They bought their house on Alvina Drive then and there for $8,000. Moving to Pleasant Hill, Barbara says, "Was like moving to the country." This view looks down Helen Drive from Gregory Lane in 1951; Monti Circle and Strandwood Elementary School were later built in the field to the left of these houses.

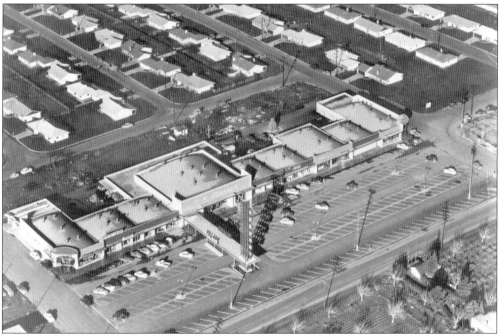

A dozen eggs from the P and X Market, a jump rope from Frank's Toyland, and a dress from Beverly Warren Apparel could all be procured in one place with the opening of Gregory Village in 1950. Flanked by orchards and tract houses, the one-stop shopping center at Contra Costa Highway and Doray Drive allowed new suburbanites to shop close to home instead of in Concord, Martinez, or Walnut Creek.

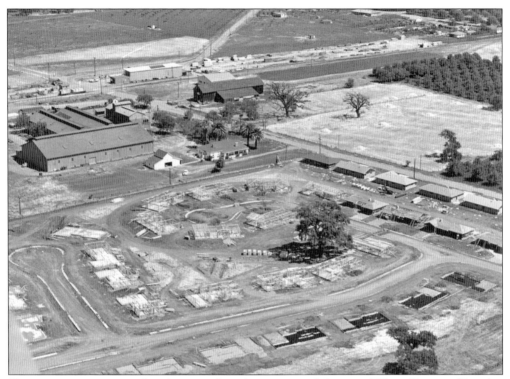

Houses in varying stages of construction line the nascent cul-de-sacs of Clarie Drive and Loralee Place, off Marcia Drive. These streets in the Fair Oaks subdivision, pictured in 1950, were built on part of the old Sherman Field airport. Hookston Road runs diagonally across the image and crosses the Sacramento Northern Railroad in the upper left corner. At this time, the buildings of the old California Wine Association winery were still standing at left center, across the railroad tracks from the site of the old Hookston stop. (Courtesy William Larkins.)

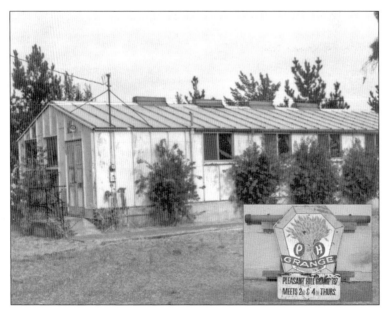

The Pleasant Hill Grange started meeting at a school shortly after World War II, but the Grange built its own community hall in 1957 on Gregory Lane near the Contra Costa Canal. Activities included booths representing Pleasant Hill at the county fair, bake sales at the Louis Store on Oak Park Boulevard, and the Dairy Dinner to celebrate National Dairy Month.

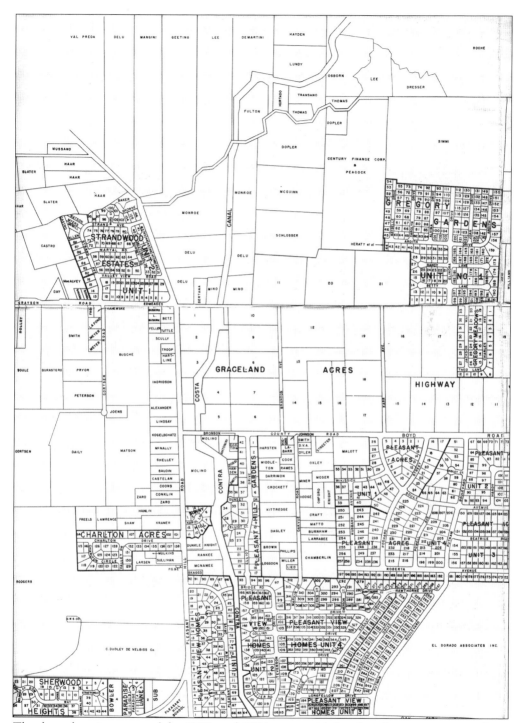

The dense housing tracts of the 1940s and 1950s, most with lots less than one acre, stand out amongst the multi-acre farm lots and older "ranchettes" on this 1949 map.

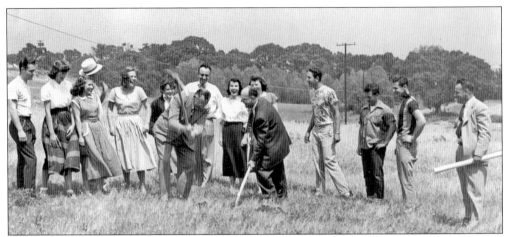

Administrators and students of the county's junior college district break ground for East Contra Costa Junior College, partner to the west campus in San Pablo. Contra Costans voted in 1948 to form the district, seeing it as a way to promote the county's economic growth. Classes at CCJC East Campus were held at various sites in Martinez until the district purchased 114 acres of the Roche ranch for $172,509, on which to build a permanent campus. A planning report described the land as "bare, except for a few scattered oaks," with "vales and knolls" and a "creek with heavily wooded banks," all of which would make a "beautifully landscaped campus." In 1958, the institution's name was changed to Diablo Valley College. (Courtesy Diablo Valley College.)

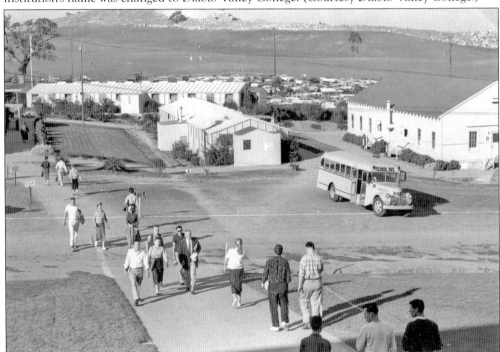

Some of the first temporary buildings on CCJC East Campus were brought from the Concord Naval Weapons Station. Ground-breaking for the first permanent structure, today's Business Education Building, took place in 1953. Golf Club Road (then called Golf Links Road) runs beyond the parking lot in this image; the ridge of the old quarry appears in the background. (Courtesy Diablo Valley College.)

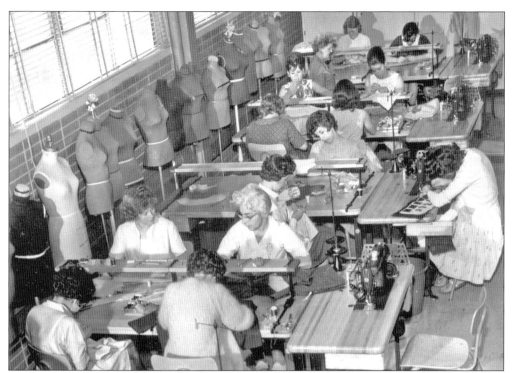
An apparel design program, shown here in the mid-1950s, was among the programs offered by the new college. (Courtesy Diablo Valley College.)

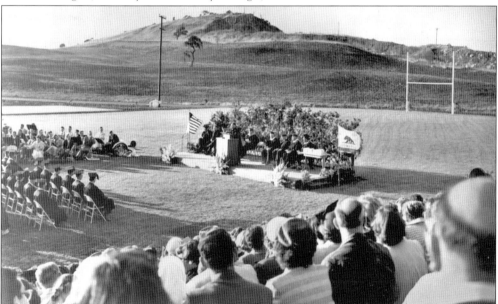
Eighty students received degrees at the first CCJC East Campus graduation in 1952. The ceremony was held on the old football field on Golf Links Road, just down the hill from Paso Nogal Road, which is visible in the background. Of all the community colleges in the state, Diablo Valley College currently boasts the highest transfer rate to the University of California, Berkeley. (Courtesy Diablo Valley College.)

Taken around 1948, this westward view shows the location of Sherman Field and other Pleasant Hill landmarks. The road traveling left to right across the middle of the image is the Contra Costa Highway. The buildings of Sherman Field are on the east side of the highway, with Pleasant Hill Motor Movies, a drive-in movie theater, to the right. The road between the two, going off in the distance toward the undeveloped hills, is Gregory Lane. The diagonal road near the bottom is Monument Boulevard. The infant stages of Highway 680 are also apparent, visible only as a cleared path going left to right through Sherman Field.

Sherman Field and the drive-in theater are shown closer up. Judging by the presence of Gregory Gardens homes at the top of the image, absent in the previous view, this photograph was taken later, probably about 1950.

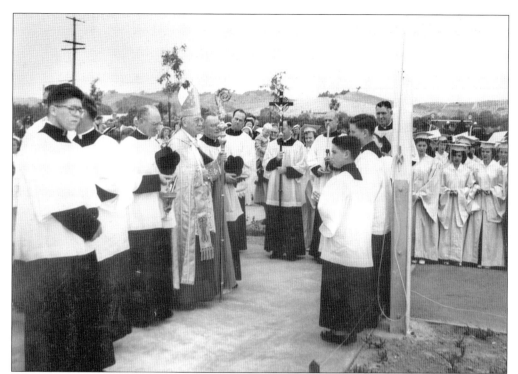

Archbishop John Mitty of the Archdiocese of San Francisco leads the dedication of Christ the King Church on May 31, 1953. Established in 1951, the parish initially met in a dilapidated farmhouse surrounded by almond trees, with the confessional located where the toilet had been. In this photograph, orchards and grapevines still cover the hills in the western part of Pleasant Hill. (Courtesy Christ the King Church.)

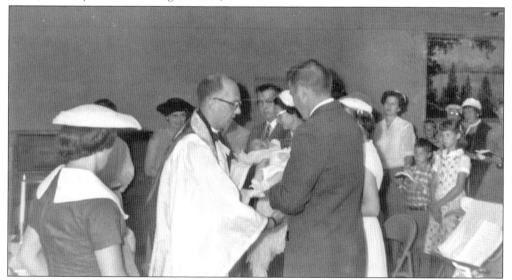

The clattering sound of bowling pins often accompanied the early services of the Church of the Resurrection, say church members. The congregation originally met in the banquet room of the Monument Bowl, beginning in 1959. Pictured here is the church's first baptism. (Courtesy Church of the Resurrection.)

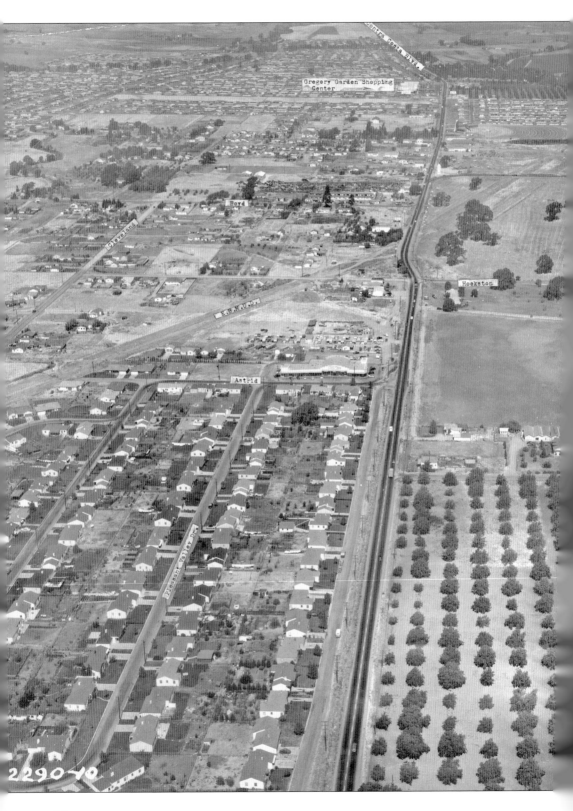

This north-facing view of the area surrounding North Main Street and the Contra Costa Highway was taken around 1953. Several streets, as well as the East Bay Municipal Utility District's Mokelumne River Aqueduct, were given labels in this photograph. The Soldiers' Monument is visible in its original location, on the triangle at Monument Boulevard and Contra Costa Highway. The building on Astrid Drive near North Main Street, with a sign stating, "Pleasant Hills [sic] Shopping Center," was later converted into the second city hall. Above the label for Boyd Road are two of the warehouses on Thomas Lane (later called Monument Plaza and Crescent Plaza), which were hallmarks of the old downtown area (see page 122). The old Hook house can be seen among the trees south of Hookston Road, to the left of the Fair Oaks subdivision.

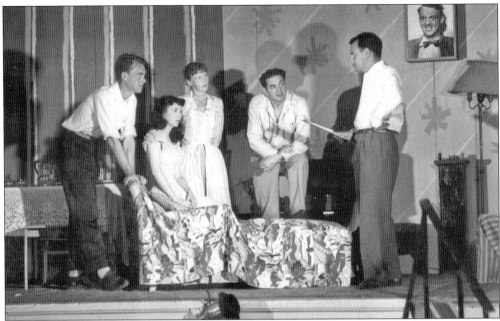

The cast of *The Glass Menagerie* prepares for opening night at the Pleasant Hill School auditorium on July 28, 1950. An article from the *Oakland Tribune* praises both the performance itself and the excellent use of space on "the postage stamp stage." (Courtesy William and Sylvia Scheuber.)

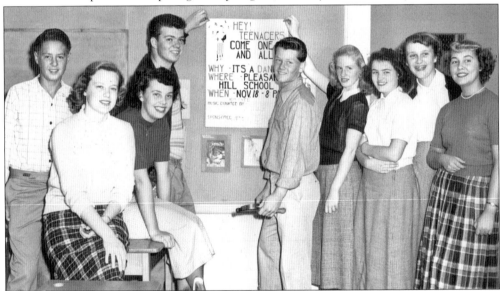

Teens advertise for a dance sponsored by the Pleasant Hill Recreation and Park District in the early 1950s. Established in 1951, the district was the community's first governmental agency and took on a vital role in developing parks, leading beautification projects, and organizing community activities. The district was also at the center of discussions regarding the community's self-government in the 1950s. By 1957, Walnut Creek had annexed 10 percent of unincorporated Pleasant Hill land that was under the district's jurisdiction, including the Larkey property. This provided an impetus for community members to discuss the possibility of incorporation. (Courtesy Pleasant Hill Recreation and Park District.)

The 1920 schoolhouse only had enough space for students until the mid-1940s. "Then came the sea of homes, the flood of people, the wave of children," an *Oakland Tribune* reporter wrote of this school. Pleasant Hill Elementary School, pictured in 1953, opened across the street from the 1920 schoolhouse in 1949. Three classes were held at the old schoolhouse until 1953.

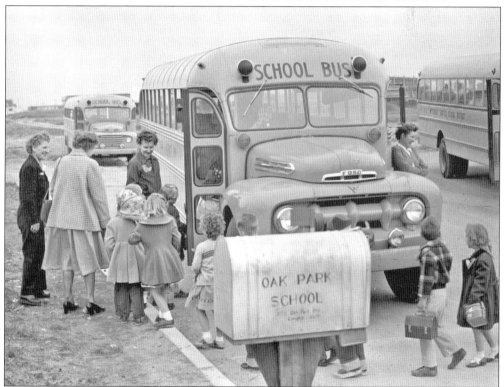

The opening of Oak Park Elementary School in 1952 came in response to intense overcrowding at Pleasant Hill Elementary. Teacher Patricia MacKay, whose pupils are seen on a field trip in 1954, began teaching at Pleasant Hill Elementary but transferred to Oak Park Elementary when it opened. To her delight, she got to trade her tiny, metal-roofed portable classroom for a kindergarten classroom at Oak Park with its own garden, carpentry area, and patio.

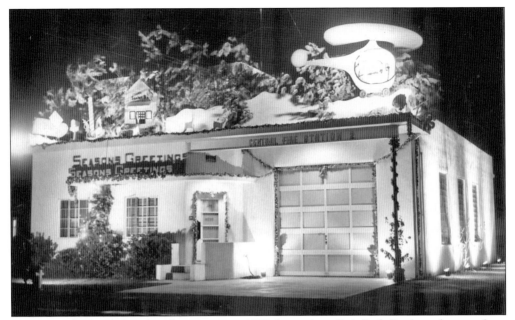

Pleasant Hill received its first fire station in 1950, located on Oak Park Boulevard across from Douglas Lane. It is decked out here, probably as part of the community Christmas decoration contest. The building now houses offices and rehearsal space for the Diablo Light Opera Company. (Courtesy CCCHS.)

The third incarnation of the 1865 schoolhouse is pictured in 1952. At this time, it was still standing on Edward Rodgers's property but was used as a home.

Ladies pose at the 1956 Pleasant Hill Women's Club fashion show and tea party, which had the theme "Flight to France." The club, chartered in 1953, held social and philanthropic events to benefit Pleasant Hill's Friends of the Library, Meals on Wheels, the Contra Costa County Girls' Center, and the Juvenile Hall Auxiliary.

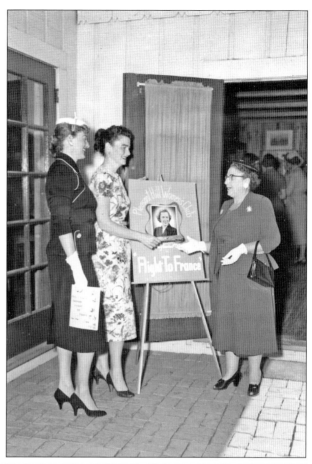

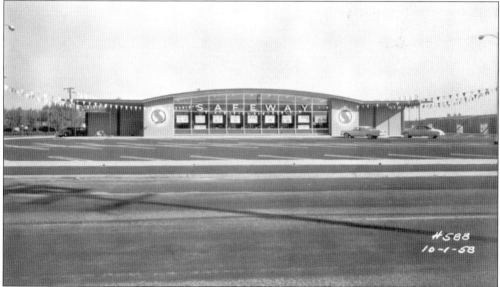

Safeway opened its first supermarket in Pleasant Hill in 1958 at the corner of Oak Park and Patterson Boulevards. Today it faces Patterson, but it originally fronted on Oak Park.

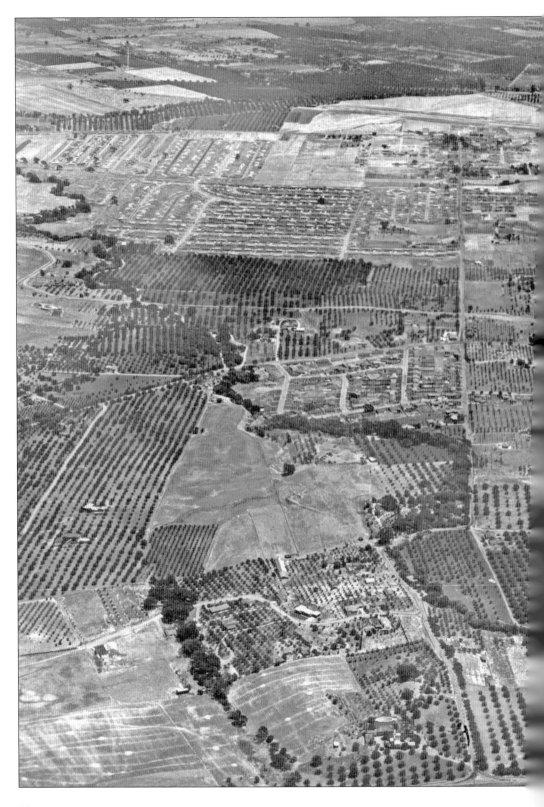

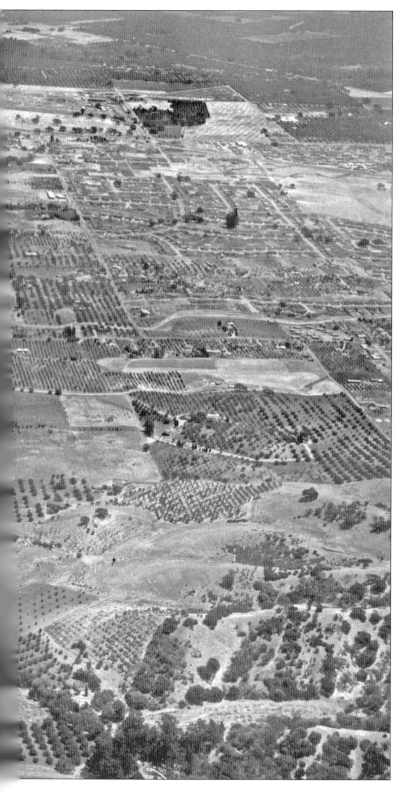

Grayson Road/Gregory Lane is the most prominent vertical road in this eastward view, taken around 1952. The most prominent horizontal line, just above the center of the image, is the Contra Costa Canal. Below the canal is the fainter Pleasant Hill Road, which bends downward after the intersection with Grayson. The double-parallelogram pattern near this intersection is the Strand Avenue area. The streets of the Gregory Gardens development are found in the upper left quadrant, with the Contra Costa Highway and Sherman Field right above them. The same vineyards and orchards seen in the aerial view on page 27 are visible in the lower center, with Grayson Creek still meandering toward the upper left corner.

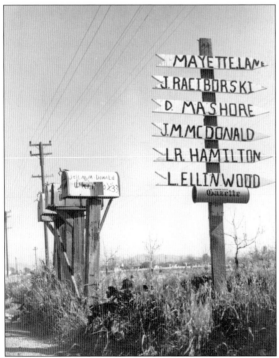

San Francisco physician Lathrop Ellinwood purchased 82 acres on the east side of the Contra Costa Highway just south of Willow Pass Road in 1912. Ellinwood used the land as a weekend retreat where he produced grain, fruit, nuts, commercial dairy milk, and eggs from 1,000 chickens. Pictured around 1955 is his family's house on what he considered a model farm.

Many roads remained unpaved into the 1950s, with signs such as this as guidance. This sign was probably located near Contra Costa Highway, judging by the mention of the Ellinwood property and Mayette Lane in Concord. These mailboxes most likely received mail through the Concord post office, while those in other parts of Pleasant Hill had Walnut Creek addresses or rural route addresses through Martinez.

Ed Kutz, great-grandson of William Dukes, perches with a friend atop a pile of trees cleared for the building of Taylor Boulevard in July 1956. Quail used to run around this once-woodsy area, according to Ed's sister Barbara Herbert, and people would go there to hunt. Named for Ray Taylor, a county supervisor who worked to get legislative funding for its construction, the boulevard's first phase opened in June 1957. Its second phase, the stretch between Pleasant Hill Road and Contra Costa Highway, opened in 1961 and provided long-awaited relief from traffic woes. (Courtesy Barbara Herbert.)

A birthday party at the Scheuber home on Strand Avenue spotlights the new pool that the family installed in 1954. The Scheubers moved to Pleasant Hill in 1948 and paid $11,300 for their house, which was considered expensive at the time. Behind the house was an old barn with horses that neighborhood children frequently visited. (Courtesy William and Sylvia Scheuber.)

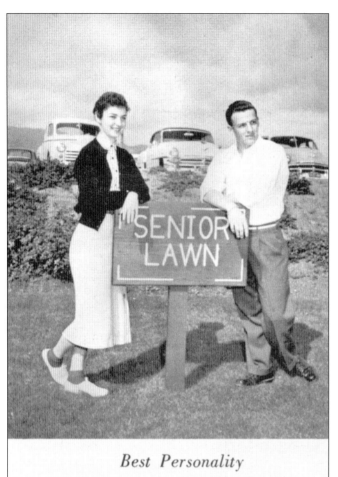

Best Personality
GLENDA GRIFFIN and JIM McDERMOTT

Voted Best Personality, two members of Pleasant Hill High School's first graduating class pose at the senior lawn. On the school's opening day in September 1953, twenty-seven teachers waited at the bottom of the main steps to greet the 534 new students. Prior to this, high school students had to travel all the way to Mount Diablo High School in Concord. A 166 percent increase in the high school student population between 1940 and 1953, however, created a need for a school closer to home. The school was almost called Loma Linda, the Spanish translation of "pleasant hill." Nancy Henrickson was a member of this first class of juniors to start at the school; there was no senior class in the first year, so her class was at the top for both years. "Talk about snobs!" she says.

Pleasant Hill High School students chose the ram as a mascot in the school's first year. In this 1958 yearbook photograph, cheerleaders rev up the stadium crowd. (Courtesy Karen Lazzarini.)

Within walking distance from Pleasant Hill High School, the soda fountain at the Alex Restaurant drew after-school crowds. The building at Oak Park and Putnam Boulevards, pictured in 1958, has housed Oak Park Liquor since the early 1960s. (Courtesy Karen Lazzarini.)

WE PUT SHOES BACK INTO ACTIVE SERVICE

Don't discard worn shoes. Bring them to us for expert repairs that will add many months of handsome service to their life.

McKay's Shoe Service

Around the corner from the Bank of America

GREGORY VILLAGE PLEASANT HILL

A Real Special On Laundered

Shirts 20¢

• WITH ORDER OF DRY CLEANING •

GREGORY CLEANERS

GREGORY VILLAGE MU 2-9741

Spring Cleaning Time

LET US WASH AND DRY YOUR

★ Blankets ★ Drapes

★ Spreads ★ Shag Rugs

Phone MUlberry 5-7643

(Around the corner from the Bank of America)

GARDEN WASHETTE

MUlberry 5-7643

GREGORY VILLAGE PLEASANT HILL

to flatter you!

Yes, we put the accent on you . . . distinctively style your hair to flatter your features.

MIRROR OF BEAUTY

MU 5-8251

GREGORY VILLAGE PLEASANT HILL

"Mulberry 5-8251" was how one would give the phone number for Mirror of Beauty Salon in 1959. These advertisements from a 1959 issue of the *Pleasant Hill News* show one of the old phone prefixes: MU (Mulberry). MU and YE (Yellowstone) are the origins of the 68 and 93 that begin many local phone numbers today.

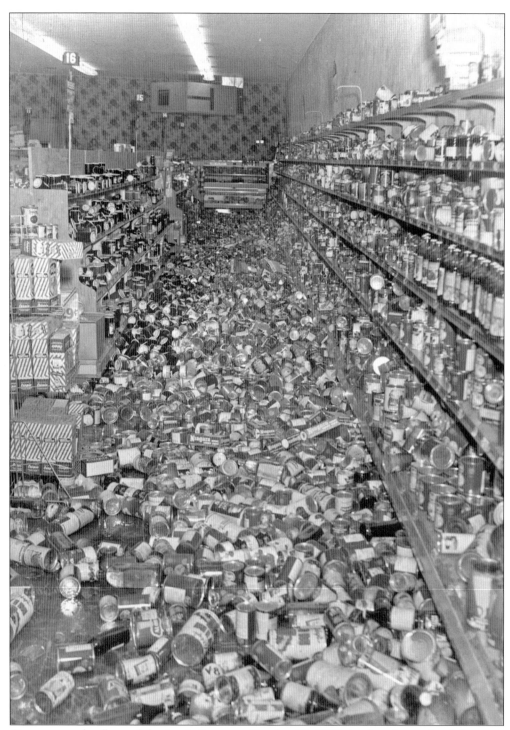

Cans carpet the floor of the Louis Store on October 23, 1955, in the aftermath of the most powerful tremor to strike the Bay Area since the 1906 earthquake. The quake hit at 8:11 p.m. and measured 5.5 on the Richter scale. A man in Oakland's Montclair district reportedly leapt from his car, yelling, "It's an atom bomb!" (Courtesy CCCHS.)

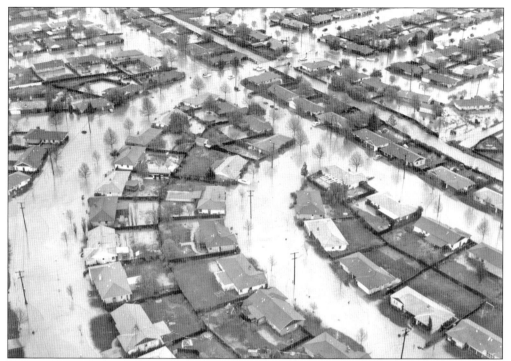

Belva, Beverly, Maureen, and Maxine were caught in a heavy rainstorm without their raincoats in April 1958. Residents of these, and the other female-named streets of the Gregory Gardens neighborhood, took the brunt of several days of rainfall when Grayson Creek spilled out into the streets. The bridge near the upper center of this image crosses the swollen creek as part of Elinora Drive; Ardith Drive is to the left of it.

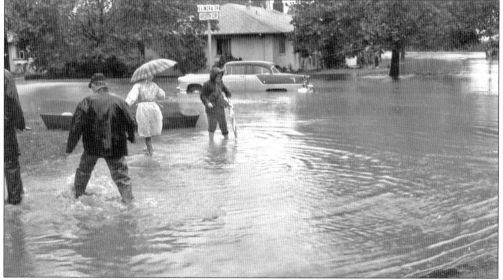

Floods like this had occurred before in the area, and longtime farmers knew that flooding in these new developments would be an issue. This one was by far the worst: 1,000 homes were hit by the flood, with damage set at $3 million. Broken garage doors, upset furniture, and inability to leave the house were among the inconveniences residents experienced.

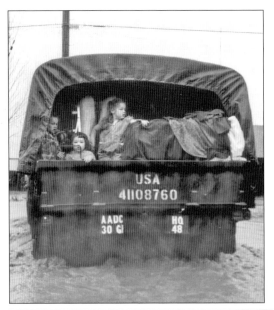

Three children of the Stiles family peer out of a National Guard truck. Some residents were evacuated to school buildings, but the Stiles family was taken to a neighbor's home on Leslie Drive. When the water reached that house, the family fled again, this time by rowboat. Nine years later, residents approved a tax to improve drainage and water control to prevent future flooding. (Courtesy Lesley Stiles.)

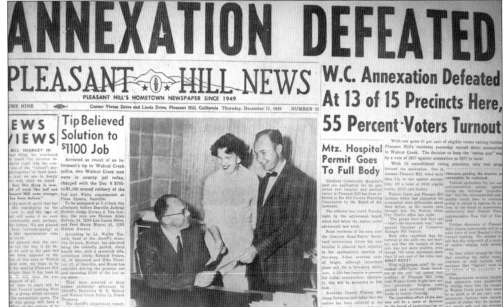

Walnut Creek's 1959 attempt to annex all of Pleasant Hill raised issues ranging from taxes to streetlights to community identity. A *Pleasant Hill News* editorial warned, "We don't believe Walnut Creek has the slightest interest in the people of the area, but literally drools over the prospect of the open spaces that would make nice light industrial developments." Some proposed a borough-type government for all Central County, toward which annexation would be a step. One supporter wrote, "No area would have to worry about losing its identity. All large cities have their different well-known areas such as San Francisco with its Marina District, Twin Peaks, Nob Hill and many other districts." Ultimately, Pleasant Hill voters defeated the proposal 2,837 to 2,077, and the community ended two decades of unprecedented growth by planting the seeds of self-government.

Five

1960s–1970s

"A dozen subdivisions looking for unity," as one civic leader described the community, symbolically found that unity on November 7, 1961, when voters approved the city's incorporation 3,173 to 2,207. Briefly stated, the debates that led up to this moment had centered around what incorporation would mean in terms of taxes and services, but residents also expressed a desire for Pleasant Hill to gain its own identity distinct from the surrounding cities. The first tasks of the new city government were to improve police protection, plan for long-range sources of revenue to fund community facilities and services, and start up a planning program for a city that was projected to have between 65,000 and 80,000 residents by 1990. The first planning committee formed in 1962, handling topics such as streets and industrial areas, as well as the "general character of Pleasant Hill" and "city beautification." In these and other ways shown in this chapter, the community's search for identity took on a new dimension as a quest for an image.

As residents sought this image, many lamented what they saw as the uniformity of suburbia. The city council, conscious of the leveling of the landscape, approved a policy to prevent the flattening of hills, noting that they provide a "refreshing relief" from "what would otherwise be a rather monotonous plain." Many suburbanites also harkened back to earlier times in search of tidbits of uniqueness to set their community apart. Romanticized images of an imagined past and discourse of country living fit this bill, yet in opposition was the much-publicized attractiveness of modern living. As the 1970s moved on, parcels of farmland were few and far between, and the new BART and bus systems made it more and more difficult to think of Pleasant Hill as the country.

During this period, residents began to relate Pleasant Hill to popular notions of life in suburbia. A 1967 article in the *Oakland Tribune* discusses Pleasant Hill in this light, describing the stereotypes of the suburban nuclear family with "the mandatory station wagon in the garage." In this article, one Pleasant Hill resident jokes about his divergence from the rules of suburbia, saying, "If I don't feel like shaving for two days, I don't shave." Fueled by media portrayals of suburbia, ranging from *Leave It to Beaver* to *Sunset* magazine, many came to see suburbia as not just a place, but a lifestyle.

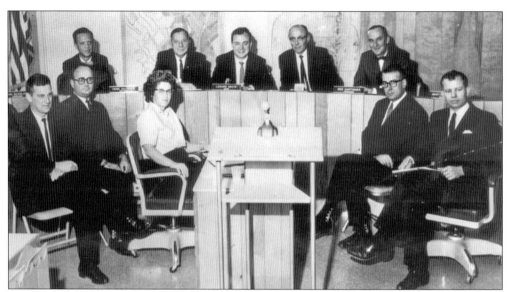

On the same ballot, residents either approved or rejected incorporation and simultaneously voted on five city council members if incorporation passed. Pictured here from left to right (second row) are councilmen John Scaglione, Frank Salfingere, Lenard Grote (the first mayor), Ben Hartinger, and Martin McLaren (who replaced Frank Hanrahan shortly after the election), with city staff members in the first row. A month after incorporation, a county conference of mayors welcomed the councilmen of the "infant" city with baby bottles, rattles, and bibs, stating in all capital letters, "A New City Is Born. Pleasant Hill, California."

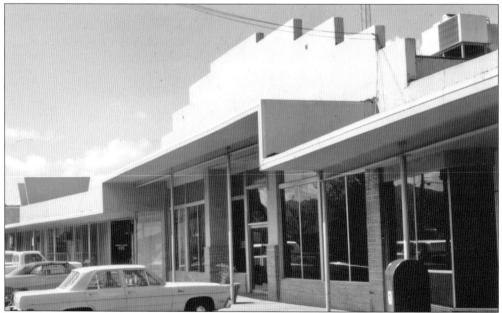

The first city hall stood next to the 1920 schoolhouse (see opposite page), but the Rosal Market building (formerly King's Market) at North Main Street and Astrid Drive was selected as the second city hall in 1962. On November 1, 1962, city agencies held a "city hall–warming" dance and buffet that also celebrated the city's first birthday. Though intended as a temporary home, the building remained in use until 1991.

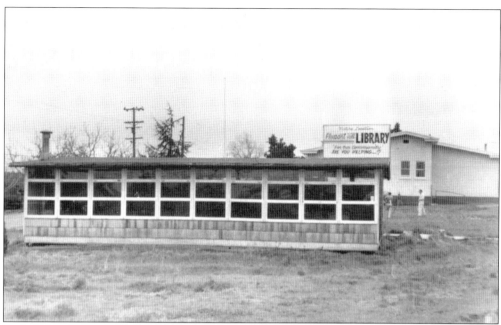

Pink and apple green were the colors of the first library, according to Sylvia Scheuber, who helped paint it when it opened in 1954. Converted from Pleasant Hill School's side building, the library's 1,200 square feet could barely fit 26 people and a growing book collection. Four years later, a new location for the library would be chosen and the little building would morph from city hall to police storage to the VFW post, as it is today.

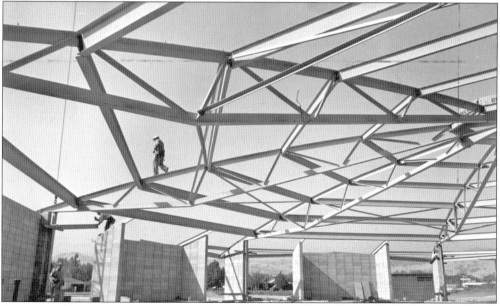

Bare trusses hint at the new library's octagonal shape and umbrella-like roof during its construction in 1961. The building, which opened on August 8, 1961, had 10 times as much floor space as the old one and combined the central library and the Pleasant Hill branch into one. The adjacent buildings were used as county offices and a clinic until the library expanded into them. (Photograph by Bethlehem Steel.)

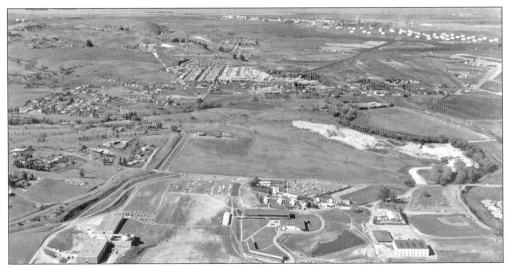

A quarry that was once a prominent feature of northern Pleasant Hill is shown here in 1961. Located just north of Diablo Valley College and Golf Club Road, this scar in the land at left center is where the DVC Shopping Center, including K-Mart, Safeway, and Round Table Pizza, was built. Camelback Road follows the lower left edge of the former quarry, and Chilpancingo Parkway follows part of the upper boundary. Today's Old Quarry Road slices through what was the left side of the quarry. (Courtesy Diablo Valley College.)

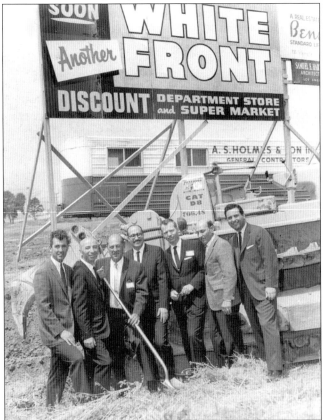

City councilmen and businessmen break ground for the White Front store on Contra Costa Boulevard north of Golf Club Road. It was later the site of Treasury, Gemco, and Target stores. Both Pleasant Hill and Pacheco (which had its own plans for incorporation that never came to fruition) wanted this "juicy tax plum," as the *Contra Costa Times* called the area. The county board of supervisors ultimately excluded the 42 acres from the Pacheco map, allowing Pleasant Hill to annex the site, which was projected to bring in $100,000 a year in sales tax revenue.

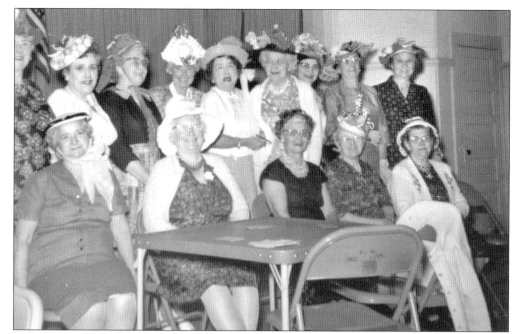

Ladies of the Pleasant Hill Senior Center show their headdresses for the 1960 Easter bonnet parade and egg hunt. The first seniors' group met in 1954 at the 1920 schoolhouse and in other facilities before moving into its current building, a former army barracks from Camp Stoneman in Pittsburg. Over the years, the seniors have planned fashion shows, dances, and group vacations, among other events. (Courtesy Pleasant Hill Senior Center.)

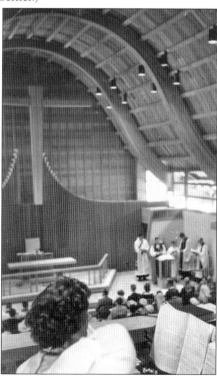

Having moved on from their first home at Monument Bowl, Church of the Resurrection congregants dedicated their new building at Gregory Lane and Kahrs Avenue in 1962. The church's unique shape can be seen here on dedication day from the organist's vantage point; the architect intended the "rustic" wood design and curved roof to blend with the rolling hills. Interestingly, at the same time that developers flattened hills and paved over fields, this church's design is a symbolic attempt to bring development in line with the land's natural topography. (Courtesy Church of the Resurrection.)

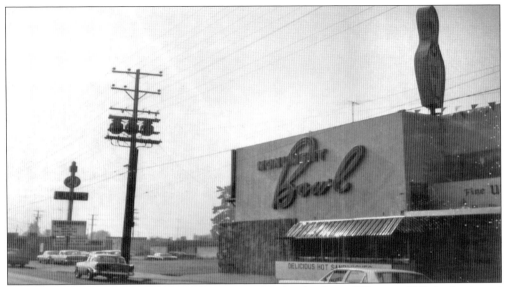

The photographs shown through page 92 were taken by the City of Pleasant Hill Architectural Review Committee, mostly in 1963 and 1964. The committee developed guidelines for the types of signs businesses could use, setting height limits, banning flashing signs, and limiting rotating signs. These photographs, taken to document the signs, give an idea of how the city's commercial areas looked in the 1960s. The first of these images shows Monument Bowl, later called Pleasant Hill Lanes, which was located on the west side of Contra Costa Boulevard north of Boyd Road. The bowling pin, by the way, passed the committee's guidelines and survived until the building was razed in 1998. (Courtesy PH Planning.)

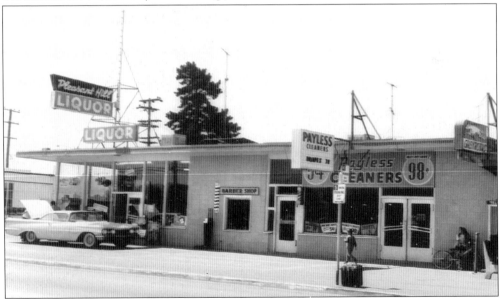

The Pleasant Hill Greyhound bus station was a tenant in one of the first commercial structures on Contra Costa Boulevard near Monument Boulevard. It opened in that location in 1946 and later moved to this building near Boyd Road. A popular bus destination, frequented by Pleasant Hill families, was an ice cream shop next to the Greyhound station in downtown Walnut Creek. (Courtesy PH Planning.)

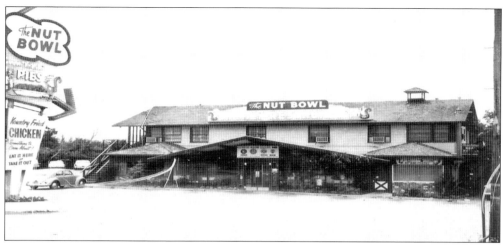

The Nut Bowl, a family restaurant on North Main Street south of Oak Park Boulevard, was a meeting place for service organizations like the Lions and Kiwanis Clubs. Until the late 1950s, this building housed the Farmer's Feed and Supply Store; it was razed in 1975 for the construction of a Black Angus restaurant. (Courtesy PH Planning.)

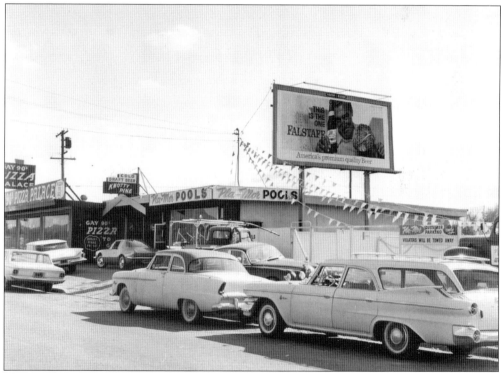

The Gay Nineties Pizza Palace, located on North Main Street and Hookston Road, celebrated its grand opening in October 1959. Pictured in 1969 with its neighbors, the Knotty Pine Tavern and Pla-Mor Pool Supply, it was a family restaurant that drew a nighttime bar crowd. On weekends, musicians playing Dixieland music entertained the crowd, and according to a former owner, the most beer they ever sold in one night was seven and a half barrels. The business remained open until the 1990s, when it was razed to build a new Highway 680 on-ramp. (Courtesy PH Planning.)

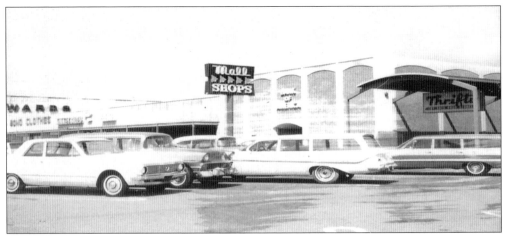

Montgomery Ward's opened in 1962 on Monument Boulevard east of Highway 680. The regional manager of the store advertised the construction plans in the *Pleasant Hill News*: "Wards Pleasant Hill store will incorporate the most modern concepts in merchandising and display.... Customer conveniences, service, and attractive merchandise displays are uppermost in our planning." The new store would be 150,000 square feet with parking for 1,700 cars, and the Contra Costa Shopping Center, of which it was a part, would offer "one-stop-shopping in comfort." Mayor Lenard Grote proclaimed in a *Contra Costa Times* article that the store's opening "signaled Pleasant Hill's graduation from a bedroom community." Ward's remained open until the first years of the 21st century, when Kohl's acquired the building. (Courtesy PH Planning.)

A miniature golf course was once situated on Trelany Road, which formerly ran all the way through from Cleaveland Road to Contra Costa Boulevard. A hot tub business later operated on this site. These buildings stood where the parking lot for Bed Bath and Beyond is today, off Crescent Drive. Note the bungalow-style house to the left, probably left over from the Highway Junction ranchette subdivision. (Courtesy PH Planning.)

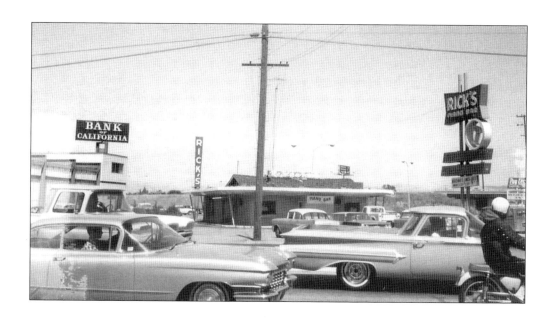

The shopping center on the east side of Contra Costa Boulevard between Monument Boulevard and Gregory Lane included Payless, the Bank of California, and Rick's Piano Bar. Payless opened in 1958, and the bank in 1961; an article in the *Pleasant Hill News* described the plans for the bank: "It will be a modern structure of a rigid steel frame construction, with large areas of glass and precast concrete. The flexibility of the design allows for future enlargement of the bank's quarters with retention of the architectural style." Rick's Piano Bar was a lively place frequented by World War II veterans, and the parking lot in this center was a popular place for carnivals. Concord tried unsuccessfully to annex the center in 1960, and the empty buildings were considered an eyesore and were the subject of controversy in the 1990s. They were ultimately torn down for the construction of the Courtyard Shopping Center; Payless was a tenant until it was replaced by Rite Aid.

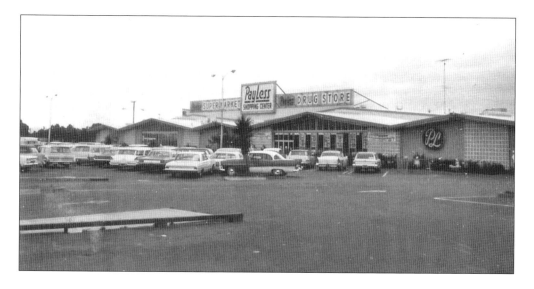

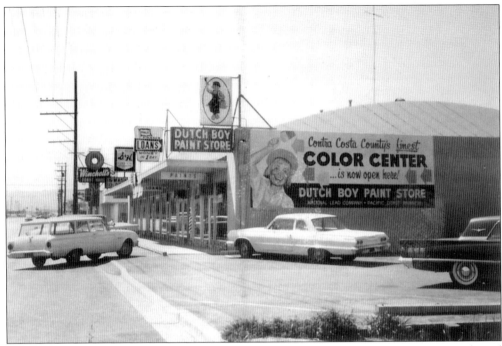

The building that contained Dutch Boy Paint in 1963 still stands on Contra Costa Boulevard south of Doris Drive. Nat Russo's barbershop also opened here in 1963 (see page 105). (Courtesy PH Planning.)

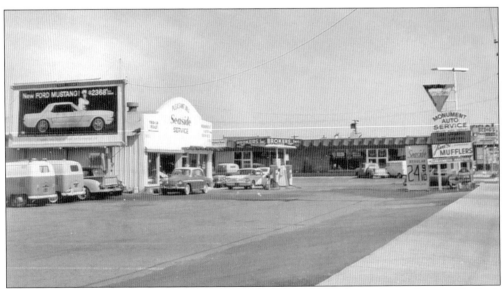

Seaside Service, at Contra Costa Boulevard and Woodsworth Lane, was later taken over by Jim's Mufflers, whose sign is seen at right. The building now houses Deb's Flower Market. Note the prices for a new Ford Mustang and a gallon of gas. (Courtesy PH Planning.)

The Bazar store was a combination supermarket and department store in the building that now houses Longs Drugs and Mervyn's. When passing through the parking lot, one crosses the city limits to the Sun Valley Mall in Concord, at right. This property was originally considered part of unincorporated Pleasant Hill, but the mall developer worked with the City of Concord to have it annexed. (Courtesy PH Planning.)

Dandy's Drive-in, at the corner of Contra Costa Highway and Trelany Road, was later the home of Nation's Giant Hamburgers. The barbershop to the right of Dandy's later housed the Mexican Burritos Restaurant. (Courtesy PH Planning.)

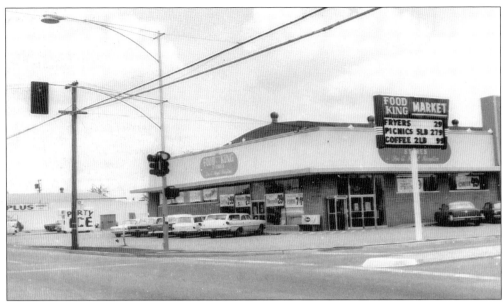

"A New Store for a New City" was Food King's slogan when it opened on the east side of Contra Costa Boulevard, north of Beth Drive, in December 1961. "Pleasant Hill and the Pleasant Hill Food King Market shall grow together," the owner told the *Pleasant Hill News* a month after the city's incorporation. The building to the left was Hogan's Surplus Store. (Courtesy PH Planning.)

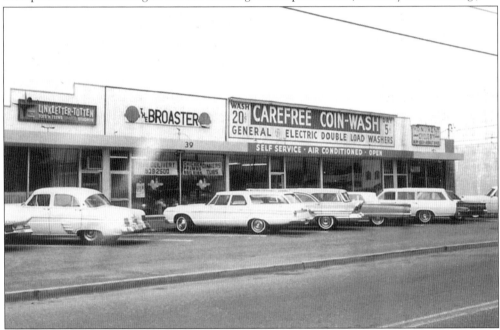

"The flow of new businesses into Pleasant Hill continues with the opening of these three shops at the Monument," stated the *Pleasant Hill News* on July 5, 1961, referring to this shopping center. Carefree Coinwash, the "neatest, cleanest, most comfortable coin laundry in California," offered periods of free washing and drying as a grand-opening promotion, and Pleasant Hill Florist (later replaced by the Broaster) offered "free orchids for all the ladies." The complex was located on the north side of Boyd Road, across from the Soldiers' Monument. (Courtesy PH Planning.)

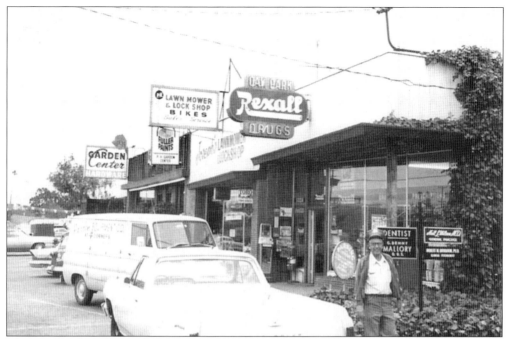

This strip mall, at the southwest corner of Oak Park Boulevard and North Main Street, was part of the once-proposed city of El Dorado Park. Residents of the area bounded by Oak Park and Putnam Boulevards, Geary Road, and North Main Street circulated petitions for its incorporation, which never came to fruition. (Courtesy PH Planning.)

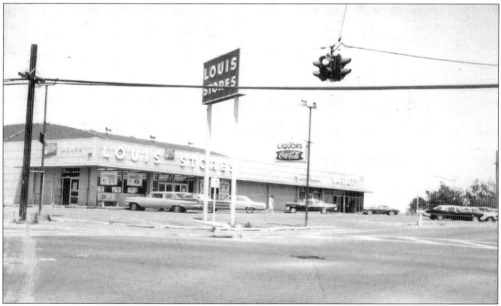

The northeast corner of Pleasant Hill Road and Gregory Lane has been the site of a number of stores. In the early 1950s, Edward Delu (brother of Louis Delu) owned a grocery store there. In 1959, a Louis Store opened, advertising its "thrifty food value" and "friendly, courteous service." In the 1980s, the building served as a liquor store and then the Pleasant Hill Tack and Feed; in 2003, Walgreens constructed a new store here. (Courtesy PH Planning.)

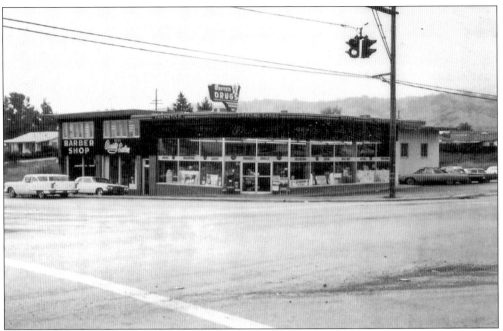

The Warren's Drugs building, at the southwest corner of Pleasant Hill and Grayson Roads, was later occupied by Produce King and is now home to Pleasant Hill Market. Note the suspended, two-light traffic signals. (Courtesy PH Planning.)

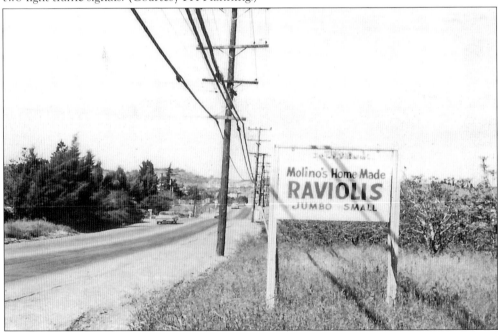

After Peter and Emilia Molino moved to Pleasant Hill full-time, they opened Molino's Raviolis and sold these and other Italian foods out of their home. Emilia used a secret Northern Italian recipe and developed a following of ravioli fans. People who knew her from the family's café in Emeryville made special trips to Pleasant Hill, and during the holidays, she worked feverishly to accommodate all the orders. (Courtesy PH Planning.)

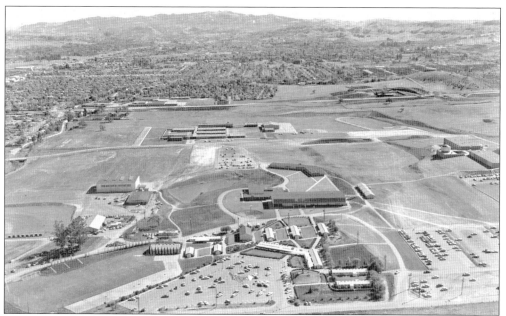

College Park High School stands beyond Diablo Valley College near the center of this 1961 photograph. The school district purchased 52 acres off Viking Drive, using 40 to build the $2-million high school, which opened in 1961 and was intended for 1,000 students. The other 12 acres were used for Valley View Middle School, which was later built to the left of College Park. (Courtesy Diablo Valley College.)

When the College Park High School Falcons hatched, so did a cross-town rivalry with the Pleasant Hill High School Rams. Evidence of the rivalry included garbage cans painted like Campbell's soup cans containing "Creamed Ram Soup." College Park's 1968 cheerleaders pose on the football field in front of the tract houses on Norse Drive. (Courtesy College Park High School.)

The first Fiesta del Diablo was held in 1963 as a celebration that constructed a romanticized link to Pleasant Hill's past. Here the 1971 Fiesta Committee meets at Jerry's Beefburgers at Contra Costa and Taylor Boulevards. According to 1962 *Daily Transcript* and *Pleasant Hill Post* articles, the city almost hired a historian to answer the question, "What is unique about Pleasant Hill?" and to "give the city an identity which would set it apart from any other town in the area." The planning commission chairman ironically hoped the "annual festivities—based upon historical fact instead of commercial enterprise—might well yield the city many thousands of dollars in annual revenue."

Supporters of the Pleasant Hill Rebels football team run a Fiesta carnival game in the parking lot of the Contra Costa Shopping Center. The "historically based" events included a beauty pageant, parade, and athletic tournaments. As a brochure stated, the Fiesta celebrated "the Spanish and Indian history and folklore of the 'Devil Mountain' region of which Pleasant Hill is centrally located," and a masked ball put "an accent on Spanish and Indian theme costume." A birdlike quadruped named Puy attended events, advertised as the "spirit and protector" of Mount Diablo who supposedly scared away Spanish soldiers in 1806.

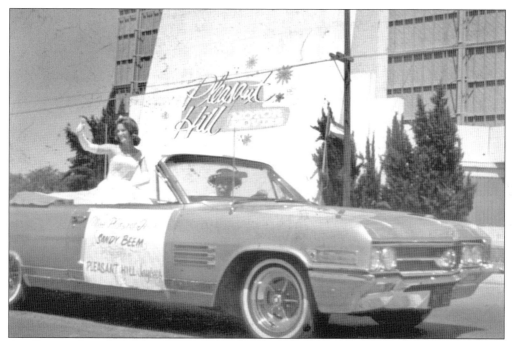

A yellow-, red-, and blue-flowered logo marks Pleasant Hill Motor Movies, the drive-in movie theater formerly located on Contra Costa Boulevard (seen on page 62). The theater provides the background for the 1964 Fiesta del Diablo parade, featuring Miss Pleasant Hill and her sombrero-wearing escort. Teenagers jokingly referred to the drive-in as the "Passion Pit" and sometimes hid friends in the trunk of the car to avoid paying admission. The drive-in was demolished in the late 1970s, and the site became the Pleasant Hill Plaza shopping center.

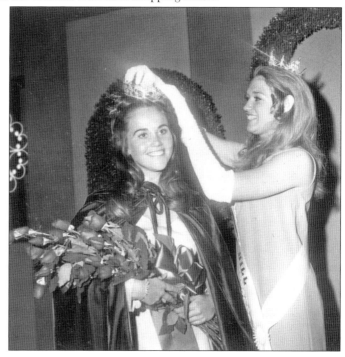

Miss Pleasant Hill 1971 receives her sparkling crown and prepares to reign over the Fiesta. The brochure for the 1963 Fiesta stated that Miss Pleasant Hill candidates all had "a rare 'beauty' which was found in many of the Spanish senoritas who lived here over 100 years ago."

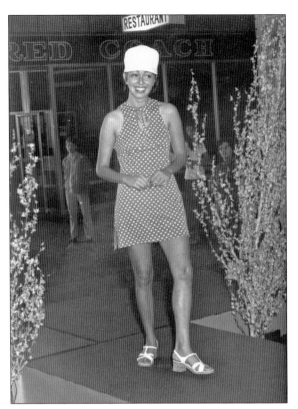

The cement and brick interior of the Contra Costa Shopping Center becomes the catwalk for a fashion show participant in the 1972 Fiesta del Diablo.

An olive-colored folder advertises the Valley High tract, built in 1965 on the hill near Elderwood Drive. Billing the development as "the ultimate in gracious country living," the realtor describes the "varied selection of terraced level lots fashioned from hills and valleys of Pleasant Hill," "unexcelled views," and a promise for "you and your family to feel like you are living on 'top of the world.'"

OVERLOOKING THE SUROUNDING COUNTRYSIDE

VALLEY HIGH

PLEASANT HILL

$32,500

AN INNOVATION of OUTDOOR-INDOOR living with the PATIO KITCHEN, coupled with beautiful view sites, makes for gracious living in VALLEY HIGH!

THE PROFUSION of GLASS in Kitchen and Family Room takes full advantage of the wonderful possibilities of INDOOR-OUTDOOR living. - - - STEP SAVER ceramic tile serv-thru counter to the Patio area. - - Beautiful - - Convienant - - Family Oriented - - the PATIO KITCHEN

CENTRAL HALL floor plans, 3, 4, 5 bedrooms, 2 and 3 baths, and a choice of architectural designs. - - - MISSION - - SPANISH - - CONTEMPORARY - - RANCH

EVERY CONVENIENCE has been incorporated in the homes of VALLEY HIGH: from underground utilities (including T.V. cable) and the latest of WESTINGHOUSE built-ins to complete insulation makes VALLEY HIGH the ultimate in VALUE!

...built by HARDESTY

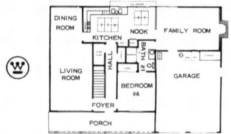

FOR MORE INFORMATION ON THESE
TRULY FINE HOMES CALL

H. L. "KIRK" KUYKENDALL
WILKE REALTY, INC
4670 CLAYTON ROAD
CONCORD, CALIFORNIA 94520

682-6560

4670 CLAYTON ROAD
CONCORD, CALIFORNIA

A flyer in the Valley High promotional folder touts the joys of these "truly fine homes." Other floor plans in the folder reveal the Yosemite, the Sequoia, and the Lassen, costing $31,250, $27,950, and $25,950, respectively.

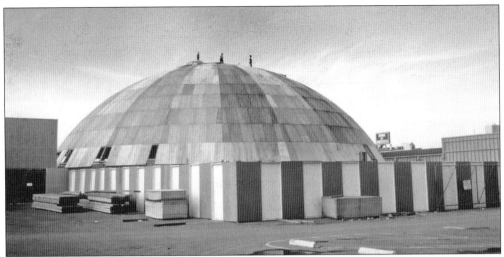

Some 900 tickets were sold for the champagne reception that accompanied the first movie, *Doctor Zhivago*, shown at the Dome movie theater on February 27, 1967. The cinema appears here under construction in January of that year. Built to link up with the mall shops of Contra Costa Shopping Center, it was the first dome theater on the Highway 680 corridor and had 895 seats.

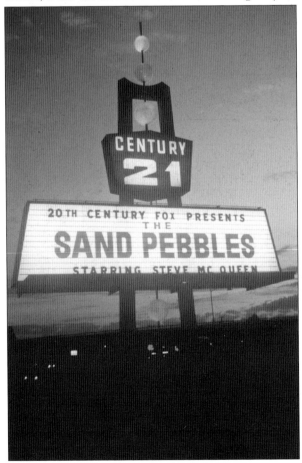

A purple and orange sunset glows over the similarly colored tower that once stood in the parking lot outside of the Dome theater.

The city's logo in 1965, as seen on official letterhead, was gray and robin's-egg blue with an assortment of symbols: the Soldiers' Monument, the library, the Diablo Valley College planetarium, and the area's hills. (Courtesy Marion Corder.)

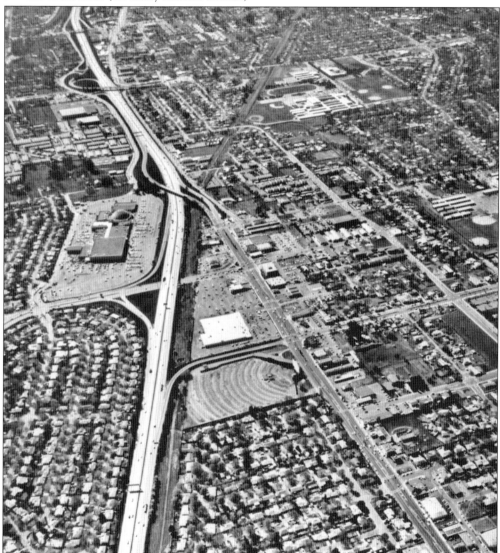

In this south-facing view, Highway 680 cuts through the city around 1970. Landmarks include the Dome theater on the left side of the freeway, and the drive-in theater on the right. The freeway increased Pleasant Hill's attractiveness by providing easier access to other parts of the Bay Area, but according to Ted Winslow, the former manager of the Pleasant Hill Park and Recreation District, it also divided the city into two pieces. This made it a challenge for the district to keep both sides equally involved in community activities.

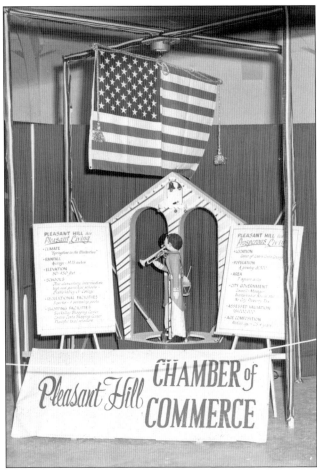

The chamber of commerce formed on November 28, 1954, and, in 1963, adopted the slogan "City Shopping, Country Living" in an interesting balance of the city's coexisting identities. This 1968 display promotes "pleasant" and "prosperous living" in Pleasant Hill, lauding its educational, recreational, and commercial establishments and its climate of "Springtime in the Wintertime."

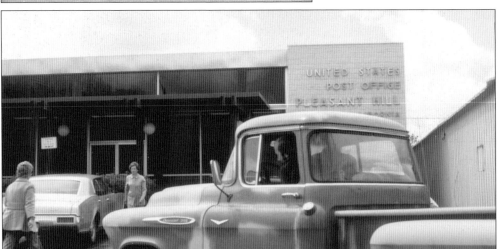

The current post office opened in December 1967 and is pictured here in 1976. The building plans promised "an attractive building of slumpstone," "a face of gleaming glass," and an overall "rustic" feel. This replaced the previous post office, which had been constructed in 1951 on the east side of Contra Costa Highway north of Doris Drive, the site of today's Taco Bell.

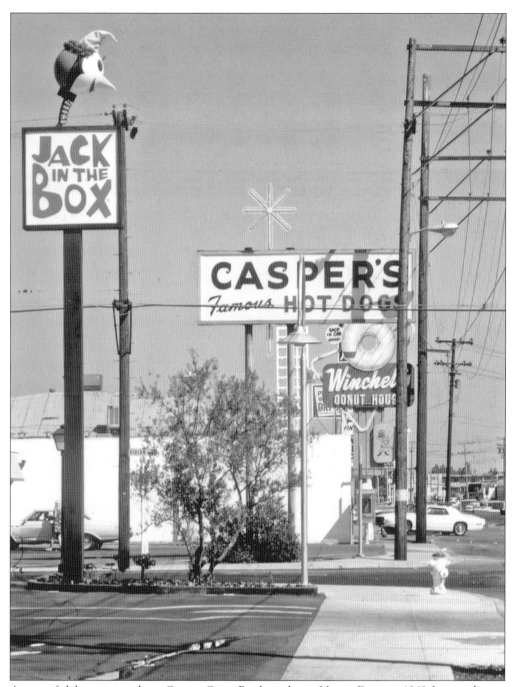

A strip of elaborate signs lines Contra Costa Boulevard near Vivian Drive in 1969. In compliance with the Architectural Review Committee, Jack-in-the-Box removed the "Jack" head from its sign, Casper's replaced its twinkling red, white, and blue sign with the smaller sign still in use today, and Winchell's replaced its green and yellow doughnut-topped sign with a simpler one. This photograph was presented in a slideshow at a 1976 community forum in order to demonstrate the scene before the phone wires were put underground, before the street was landscaped, and before the signs had "class," as the presenter said.

A new streetlight on Contra Costa Boulevard is christened in 1967. Streetlights were a hot topic in 1959 as residents considered annexation to Walnut Creek. The pro-annexation campaign argued that Pleasant Hill would get the much-desired streetlight improvements as part of Walnut Creek. Anti-annexation groups noted that Walnut Creek was barely able to handle its own street lighting.

C. Carlos Cabrera orates at a city election in 1970. In this year, city government officials received praise for the city's Architectural Review Commission and had inquiries from other cities about how to establish such a commission.

Several streets were widened and improved in the 1960s, including Contra Costa Boulevard, seen here in 1966. Statistics show that in 1969 Pleasant Hill residents owned 1.7 cars per family, the highest of all Bay Area cities. Cited in this project was the need to accommodate increased congestion with the opening of the Benicia Bridge. This view looks south near Gregory Lane, with the drive-in theater on the left and the Du-Mor Milk Depot on the right.

Street improvements were part of the city's capital improvement plan. This poster, lauding the upgrade of several thoroughfares between 1966 and 1968, shows before and after shots of each project. One resident recalls that her grandmother, who lived on Gregory Lane, lost half of her front yard when the street was widened.

Pleasant Hill's first police officers, along with clerks clad in orange dresses, pose in front of the original police office in the 1920 schoolhouse. Prior to 1970, the city had contracted with the county for police services.

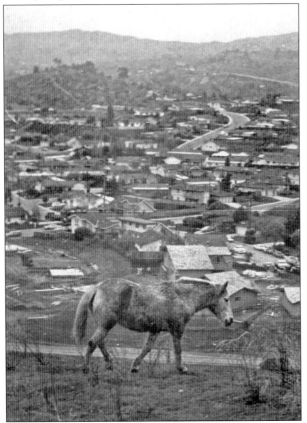

One of the former four-legged frequenters of the hill between Paso Nogal Road and the Contra Costa Country Club stands above the Valhalla Heights development in 1970. Edie Court and Odin Place, in the foreground, are under construction, and Kiki Drive and the curving Vili Way, both off Morello Avenue, are visible farther up. In July 1962, the Valhalla Heights and Valley High areas, with 1,000 future residential lots, were some of the city's first annexations. The "Paso Nogal island" turned down annexation in 1964 but eventually joined the fold of incorporation.

One of several dairies in Pleasant Hill, the Du-Mor Milk Depot was located on the Contra Costa Boulevard south of Woodsworth Lane, near today's post office. Pictured in 1972, it was named for owners Gene Dumond and Al Morgan. While many had milk delivered to their houses, residents say this drive-through dairy was quite a novelty when it opened in 1957.

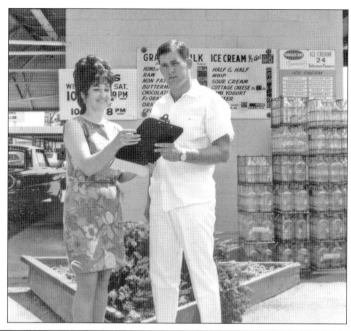

Nat Russo's barbershop had a string of claims to fame. Nat's nephew and business partner, Sal DiMaggio (right), is a cousin of the famous Joe DiMaggio. Nat and Sal are pictured here with Red Skelton (front), who passed through Pleasant Hill after performing at the Concord Pavilion's grand opening in 1975. Furthermore, Nat recalls a customer named Amos who used to come in with his sons; in hindsight, Nat believes one of the sons was Tom Hanks, whose family lived for a spell on Derby Court in Pleasant Hill. (Courtesy Nat Russo.)

The cutting of the ribbon at the new Pleasant Hill BART station on May 21, 1973, opened a new era of growth in the city. Built partially on the path of the abandoned Sacramento Northern Railroad, the system allowed for easier commuting to Oakland and San Francisco. Pleasant Hill's station was constructed in the former hamlet of Walden, which Pleasant Hill tried unsuccessfully to annex. Irene Erwin, one of a select group who ceremoniously boarded the first train in Pleasant Hill, remembers the thrill of going through the tube under the San Francisco Bay. She says, "It was something I would have never imagined here. It was like the subways of New York, but here in the Bay Area."

Belva Davis, television reporter for KPIX San Francisco, regales the crowds under the new BART station. City leaders on the platform also addressed the crowd, who wore free souvenir hats and were festooned by balloons and American flags.

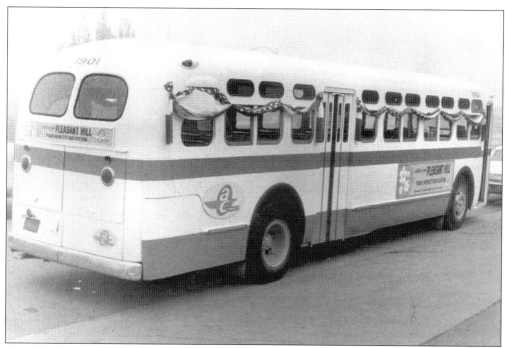

Great fanfare surrounded the inauguration of the city's first bus system on December 8, 1975. The system, operated by AC Transit, provided a long-awaited connection between Sun Valley Mall and the Montgomery Ward's shopping center and was a solution to a growing parking problem at BART. It operated in two loops—one through the center of town and another around the perimeter. The fare for adults was 25¢.

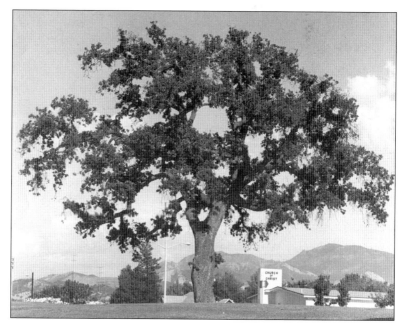

In 1974, the city council passed the Heritage Tree Ordinance, setting up a program for the recognition of the city's most venerable trees. This tree on Gregory Lane is, today, the Tree of Lights for the Hospice of Contra Costa Foundation. (Courtesy Pleasant Hill Recreation and Park District.)

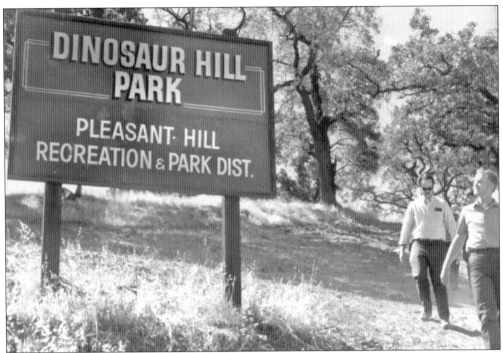

Although the hillside on which it sits resembles a sleeping apatosaurus, Dinosaur Hill Park, pictured in the late 1970s, did not receive its name this way. It was, in fact, a tree trunk that lay in the form of a large reptile that inspired a Pleasant Hill student to enter the winning name in a citywide contest in 1964. Former Pleasant Hill Elementary student Julianne Nasholts remembers field trips to the park for nature activities.

Principal Charles Murdock and his wife, Vera, pose with parents at Pleasant Hill Elementary School's PTA Pancake Breakfast in 1973. The dinosaur, seen adorning a school sweatshirt, was selected as the school's mascot because of the proximity to Dinosaur Hill Park. Changes in demographics following the baby boom affected several schools; Oak Park Elementary closed in 1976, followed by Pleasant Hill High School in 1980 (which reopened as Pleasant Hill Middle School in 1997), and Gregory Gardens Elementary in 1982 (which reopened in 1994).

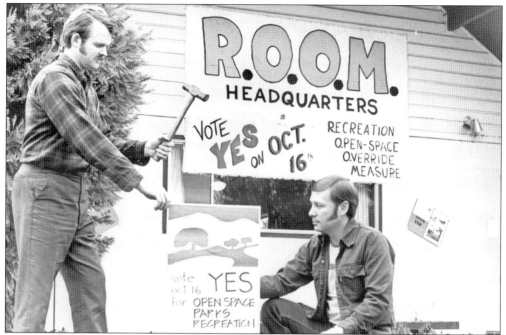

Signs at the Pleasant Hill Recreation and Park District offices (now the Pleasant Hill Senior Center) promote a campaign to save open space in 1972. In the late 1960s, many residents worried about overdevelopment and the loss of natural beauty, such as the many hills that had been flattened. The city council adopted the Hillside Ordinance in 1969, mandating that new buildings "blend in" with the natural terrain. According to this resolution, the hills "symbolize the rural or country atmosphere and proved an immediate visual escape from moments of congestion and overcrowding." (Courtesy Pleasant Hill Recreation and Park District.)

Construction on Chilpancingo Park, nestled in an old grove of cottonwood trees, began in 1978. The park was named for the Mexican city of Chilpancingo, which became Pleasant Hill's sister city in 1972 through the Friends Abroad program. Visits between the two towns and expressions of goodwill have strengthened this relationship. In 1977, when looking for a new name for the part of Concord Boulevard east of Contra Costa Boulevard, the city council debated the likes of Swamp Avenue and Bicentennial Boulevard before deciding on Chilpancingo Parkway. (Courtesy Bob Dottery.)

The A&W, standing on Contra Costa Boulevard south of today's post office, was a bright orange building that was repainted white in 1976, as pictured here. The restaurant advertised its "famous burger family" of "papa," "mama," and "baby" hamburgers and its root beer, all served by "courteous car hostesses."

In 1976, Straw Hat Pizza was located on Contra Costa Boulevard south of today's Ellinwood Drive. This area was formerly owned by an Italian man with the last name Giussi, pronounced "juicy." Nat Russo remembers Giussi's produce stand near here. In broken English, Giussi would show customers the fresh fruits and, amusingly, incorporate his own last name into the phrase, "Nice and juicy!"

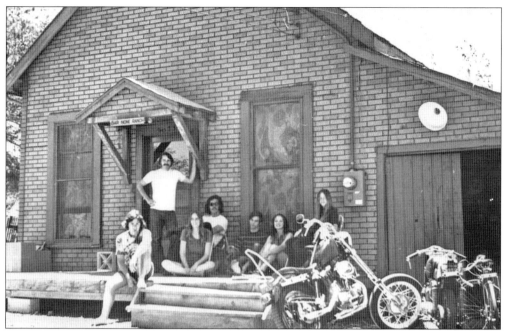

Rechristened the Bar None Ranch and sporting a faux-brick facade and psychedelic curtains, the 1865 schoolhouse on the former property of Edward Rodgers was the stomping ground of this group in the 1970s. The structure was torn down during this decade. (Courtesy FORR.)

The Sherman Acres Homes Association's float rolls up Viking Drive in front of Diablo Valley College during a celebration of the nation's bicentennial.

John and Earl Sanko were natives of Martinez who bought 20 acres of land in Pleasant Hill in 1933. The road in front of their house, Sanko Road, later became part of Taylor Boulevard. These eccentric brothers had a working ranch that housed their collection of large curiosities: wagons, a hay gatherer, and the first fire engine used in Lafayette, among other things. This "shoot-out" was part of a public event that they called the Last of the West.

The Sanko brothers gave in to pressure and sold 11.2 acres for $66,744 for the construction of a civic center. The property is seen during the 1979 ground-breaking for a new police department, which opened in 1981. This land did become the site of the community center and police department, but not the city offices, making "Civic Drive" somewhat of a misnomer. John and Earl lived on their remaining two acres until their deaths in 1977 and 1982, respectively.

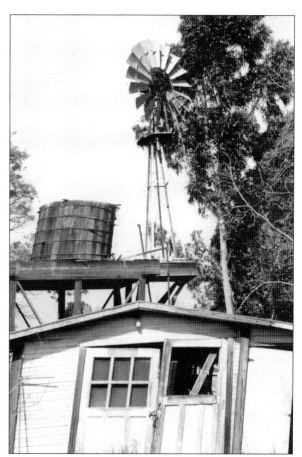

Residents once called Pleasant Hill a "city of windmills," before most of them were gone with the wind. Pictured at right is a windmill on Boyd Road near Marlee Road, and the one below was on Gregory Lane.

This photograph of the Roche ranch was taken from the hill above Lucille Drive in the late 1970s. These buildings still stand, but are now surrounded by the housing tract containing Stanmore and Roche Drives.

Having acquired the nickname "the Cabbage Patch," the Ellinwood farm ceased operations as a ranch in 1961 and operated as a truck farm until 1977, when it was sold to a developer. The Ellinwood family was unsuccessful in convincing the highway department to design Highway 680 to skirt the farm and subsequently lost all but one of the original farm structures. Yearly property taxes of $93,000 for the 82 acres led the family to sell the property. Pictured here are the last crops before the farm's conversion into a housing and business complex.

Six

1980s–Today

Finding a center had been a theme in Pleasant Hill since the city's incorporation. A 1963 planning report notes "no [previous] attempt to form a unified shopping area," with blighted conditions "detrimental to community development." The 1974 Pleasant Hill Commons Redevelopment Plan for the area around Contra Costa and Monument Boulevards began a process that culminated in the opening of a new downtown in 2000.

Although newspaper articles from the 1950s referred to the location as downtown, the redevelopment agency sought a better-defined commercial core that residents would find attractive and that would generate more revenue for the city. Financial constraints prevented a one-step massive overhaul, and the agency pursued smaller projects in the area in anticipation of a major overhaul down the line.

A radical change for the city landscape, a six-story office building called the Terraces, was one of the first of these smaller projects in the mid-1980s. A new city hall opening in 1991 provided a subsequent step, but economic factors forced several reconsiderations of the full-fledged downtown plan and delayed its implementation. Finally, in 1998, demolition of the old downtown area began, followed by a period of construction and the grand opening of the new space on July 4, 2000.

While developers were replacing old structures with new ones in the downtown, community members were working to save old structures in other parts of town. The Contra Costa Guild of Quilters, the Pleasant Hill Historical Society, and several other organizations formed a consortium to convert the 1920 schoolhouse into a historical and cultural center, which opened in 1982. The historical society also succeeded in saving the buildings of Patrick Rodgers's property from demolition for a housing development in 1987. Out of this effort grew the Friends of Rodgers Ranch, which at the time of this writing is restoring the property for the creation of a heritage park. Through efforts such as these, residents have sought to maintain historical aspects of Pleasant Hill as a part of the city's identity in a balance with new developments.

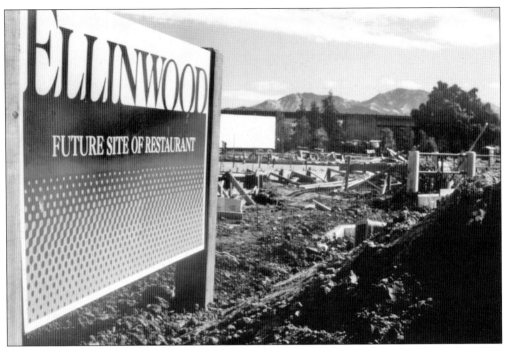

A developer advertises the next incarnation of the bulldozed Ellinwood farm in the early 1980s. Although it saddened family members to sell the property, they had high hopes for the developer to include open space in the plans. "Whatever it is, it will be beautifully done," said Lathrop Ellinwood's daughter in an article about the farm. (Courtesy Pleasant Hill Chamber of Commerce.)

Margherita Molino displays a Christmas present around 1983. Margherita, who married Peter Molino (son of Peter and Emilia), moved with her husband from Emeryville to the Molino land about 1957. She took over Molino's Raviolis when her mother-in-law's health declined in the early 1980s and, after Emilia's death, still operated the business out of the same house. While continuing to sell the ever-popular ravioli, she experimented with new foods and found her polenta pies, beef stew, and enchiladas to be crowd-pleasers. (Courtesy Margherita Molino.)

Louis Mangini has maintained the Mangini Farm, pictured above in 1983, as the last working farm in Pleasant Hill. Well known for its produce stand, selling sweet corn and fresh produce in the summer and pumpkins at Halloween, the farm has hosted events such as scarecrow contests, hay rides, and community fund-raisers since the 1960s. Below, Louis and Marian Mangini receive a check in support of the Mangini Agricultural Museum, a showcase of old farm equipment and artifacts at the fairgrounds in Antioch. (Below courtesy Pleasant Hill Chamber of Commerce.)

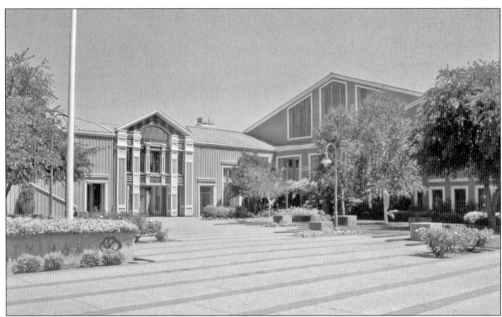

On June 8, 1991, the city dedicated its new city hall at the southeast corner of Gregory Lane and Cleaveland Avenue with music, speeches, and refreshments. The front (above) and back (below) sides of the building are shown here. The brochure from the event says that the design will "carr[y] forward the City's heritage" and blend the aspects of a park, pond, and fountain (dedicated to the sister city of Chilpancingo) with an "air of prominence and distinction." The city hall's barn-like features ironically propagate a rural heritage after the razing of the real structures on which the building was based. A 1993 article from the *Pleasant Hill Record* describes the building as "memorable" and "unique," and it has won awards for architecture. (Photographs by author.)

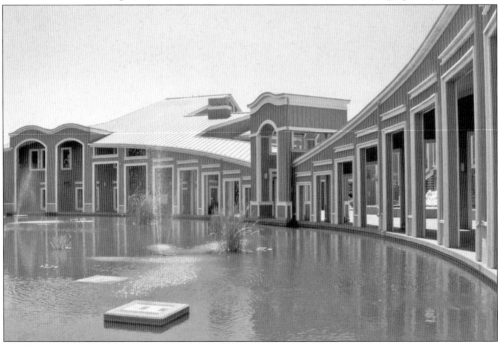

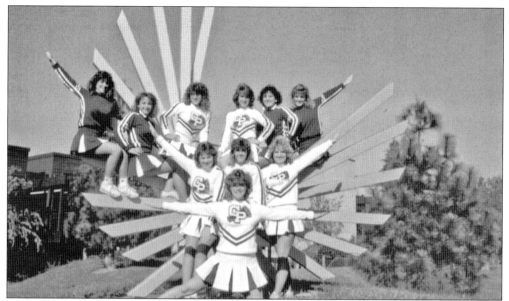

College Park High School cheerleaders strike a pose in front of *Asfothelos, the Daffodil*, a yellow sculpture by Roslyn Mazzilli purchased by the Pleasant Hill Arts Council. The sculpture was one of many efforts to create new symbols of Pleasant Hill surrounding the city's 25th anniversary of incorporation, including the distinctive huts sheltering Pleasant Hill signs at city limits and a new city seal with a tree motif. A 1986 history claimed that, with projects such as these, the city had finally created a "visible identity." Such an effort is, in truth, ongoing. (Courtesy FORR.)

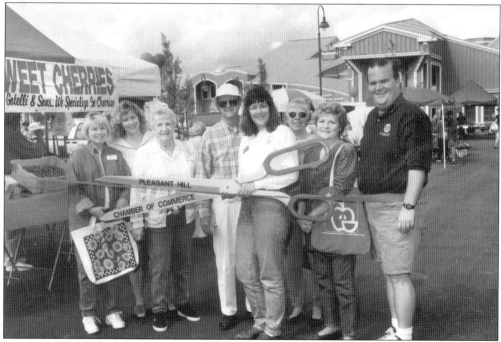

A ribbon-cutting ceremony opened the Pleasant Hill Farmers Market in the city hall parking lot on May 3, 1998. The market began in 1982 and was formerly held in the parking lot of Hillcrest Shopping Center on Morello Avenue. (Courtesy Pleasant Hill Chamber of Commerce.)

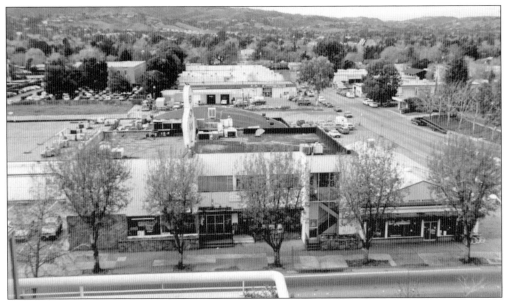

The photographs on the following pages document Pleasant Hill's downtown in 1998, before most of it was razed. Many of these buildings had been standing since the 1950s, and some since the 1940s. This image shows the intersection of Monument Plaza (now Crescent Plaza) and Contra Costa Boulevard, with Pleasant Hill Lanes in the foreground. The Aquarium fish store, a nail salon, a Baha'i center, and the Contra Costa Cyclery are to the right of it. In the background, on Monument Plaza, are Monument Car Parts and other small businesses. Borders Books stands at this corner today. (Courtesy PH Redevelopment.)

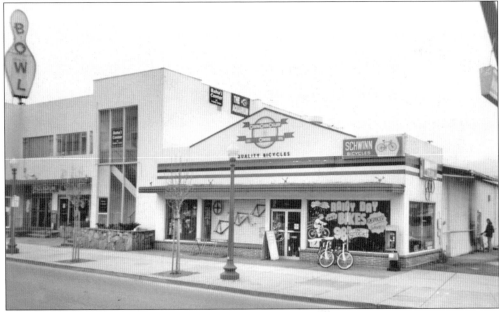

The smaller businesses of the Pleasant Hill Lanes building are seen up close in this street-level view. When the city demolished these structures in 1998, members of the Church of the Resurrection rushed to the bowling alley to save some bricks from their first home. (Courtesy PH Redevelopment.)

The former site of Nation's Giant Hamburgers was on Contra Costa Boulevard between Trelany Road and Monument Plaza. This same building was home to Dandy's Drive-in in the 1960s (see page 88). Also known for its pies, Nation's moved to Pleasant Hill Plaza when its original building was torn down. (Courtesy PH Redevelopment.)

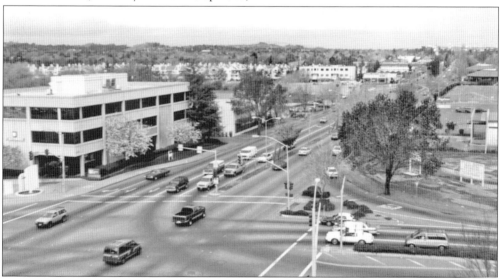

Facing north on Contra Costa Boulevard, this photograph shows the old Payless shopping center at right, just north of Monument Boulevard. The empty Bank of California and the sign for Payless are visible to the right. Today the Courtyard Shopping Center is located here. Across the street is the First Nationwide Bank building, which still stands. Looking up Contra Costa Boulevard, the view reveals Guitar Heaven, Nation's Giant Hamburgers, and Grand Auto. Beyond that, the scene with Lyon's Restaurant and the Two Worlds Center remains basically the same today. (Courtesy PH Redevelopment.)

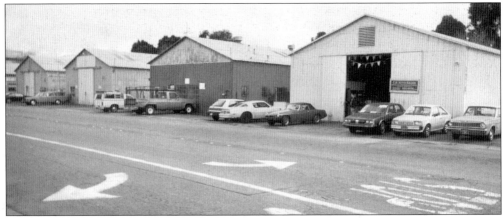

The warehouse buildings that stood on the south side of Monument Plaza, in colors ranging from white to peach to bright red, housed businesses including car repair shops, a cheese shop, and an antique shop. They can be seen in their infancy in the aerial view on page 64. The owner of one of these shops sued the City of Pleasant Hill when he was forced out of his building. Although he received help in relocating his business, he did not enjoy the same success at his new space and felt forced to change careers. (Courtesy PH Redevelopment.)

The Mexican Burritos Restaurant, with its yellow awning and bright green door, was a barbershop in the 1960s. Along with the Bug Stop, it stood around the corner from Nation's on Trelany Road. Some of the roads in the residential Trelany area were private and not well maintained; the city considered them blighted and noted "little or no property improvements, resulting in declining property values." (Courtesy PH Redevelopment.)

The pink building on Boyd Road at Contra Costa Boulevard, whose grand opening was celebrated in 1961 (see page 90), served as a television store in 1998. The other half was empty. This building, as well as Custom Glass and Screen to the right, was razed to build the parking structure for the new downtown. (Courtesy PH Redevelopment.)

Behind the bowling alley, the partially demolished thrift shop stands in contrast to the Terraces across the street at Contra Costa and Monument Boulevards. The six-story Terraces building, started in 1985, was one of the first downtown redevelopment projects. Residents initially believed this kind of high-intensity, high-rise development would provide the funds for the full downtown project, but then subsequently approved an initiative to prevent further development of this type. (Courtesy PH Redevelopment.)

City council members and community leaders celebrate the impending demolition of the warehouses on Monument Plaza in 1998. (Courtesy PH Redevelopment.)

The bright red warehouse collapses in a symbolic ushering out of the old downtown area. (Courtesy PH Redevelopment.)

Now operating the Dome movie theater is CinéArts, showing, as the company states, "The artistic side of film." The Pleasant Hill landmark is now a five-screen complex and, at the time of this writing, in danger of being razed. As one theatergoer states, "You can never replace the beauty [and] grandeur of the large dome theater." Shown above is the theater exterior, and below is the interior with its sea-foam-green ceiling. (Above photograph by author; below courtesy Thora Harshman.)

Since 1987, the Friends of Rodgers Ranch have worked to preserve Patrick Rodgers's family house at what is today the end of Cortsen Drive. After installing a new foundation, projects have included replacing the roof, rebuilding the porch, and repainting, as shown here. The Friends have also dismantled the barn on the property, preserving the wood to be reconstructed when a foundation is eventually built for it. (Courtesy FORR.)

Members of the Friends of Rodgers Ranch pose in front of the Rodgers house at a holiday event. Among the group's programs is a summer Round-Up for children to learn about farm life practices in 1860s Pleasant Hill. At this day camp, children churn butter, make ice cream, play old-fashioned games, and participate in singing and storytelling. (Courtesy FORR.)

Shortly after the new $136.35-million downtown opened, an article in the *San Francisco Chronicle* noted the lushness of the landscaping, with architectural features such as stone fountains "designed to be explored . . . not just admired." Visitors quoted in the article gave mostly positive feedback, calling it "homey" and saying that it made Pleasant Hill a destination. (Photograph by author.)

Community groups have made the arch over Crescent Drive into an icon of a new aspect of the city's identity. The oft-pictured arch is the centerpiece of an afghan that the historical groups designed for sale in 2002. Symbols from earlier years—the Soldiers' Monument, the sign at Mangini Farm, and the 1920 schoolhouse—find themselves just threads away from more recent ones such as the Dome theater and the 1991 city hall. This balance of old and new symbols is part of a complex process of envisioning the identity of a community, with each person having a different view. A new downtown or an old schoolhouse can only be one of many symbols or identities for a city. In suburbs like Pleasant Hill where development is followed by redevelopment and even further redevelopment, it is important to let the old and new coexist in order to allow for the diverse identities that make for a community's richness. (Photograph by author.)

Across America, People are Discovering Something Wonderful. Their Heritage.

Arcadia Publishing is the leading local history publisher in the United States. With more than 3,000 titles in print and hundreds of new titles released every year, Arcadia has extensive specialized experience chronicling the history of communities and celebrating America's hidden stories, bringing to life the people, places, and events from the past. To discover the history of other communities across the nation, please visit:

www.arcadiapublishing.com

Customized search tools allow you to find regional history books about the town where you grew up, the cities where your friends and family live, the town where your parents met, or even that retirement spot you've been dreaming about.